IMAGES
of America

HOPEWELL VALLEY

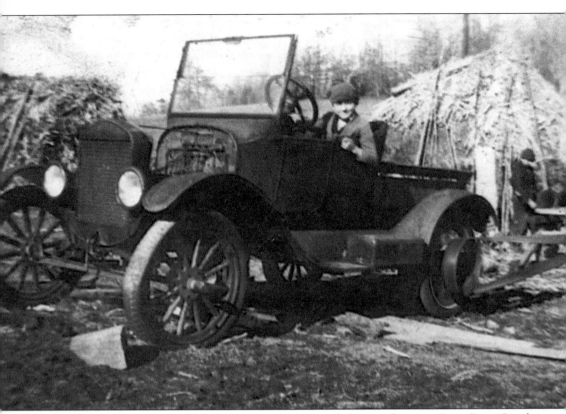

SAWING WITH A MODEL T. Carmine diCocco settled on a farm on Poor Farm Road in Hopewell Township in 1930, bringing the rest of his family over from Italy three years later. He reportedly settled here because the rolling hills reminded him of his home in central Italy near the Adriatic Sea. Pictured is his son Severino diCocco, age ten, at the wheel of a 1925 Ford Model T pickup truck, from which the rear tire has been removed. A belt was then run around the bare wheel to power a circular saw. Brother Tony diCocco can be seen behind the car, operating the saw. Their mother would throw the cut wood into a pile, to be used later in the family's wood-burning stove.

IMAGES
of America

HOPEWELL VALLEY

Jack Seabrook and Lorraine Seabrook

ARCADIA

First published in 2000.

Published by Arcadia Publishing,
an imprint of Tempus Publishing, Inc.
2 Cumberland Street
Charleston, SC 29401

Printed in Great Britain.

Library of Congress Catalog Card Number: 00-103559.

For all general information contact Arcadia Publishing at:
Telephone 843-853-2070
Fax 843-853-0044
E-Mail sales@arcadiapublishing.com

For customer service and orders:
Toll-Free 1-888-313-2665

Visit us on the internet at http://www.arcadiapublishing.com

This book is dedicated to our children, Thomas Seabrook and Michele Seabrook; may they have fond memories of growing up in Hopewell Valley.

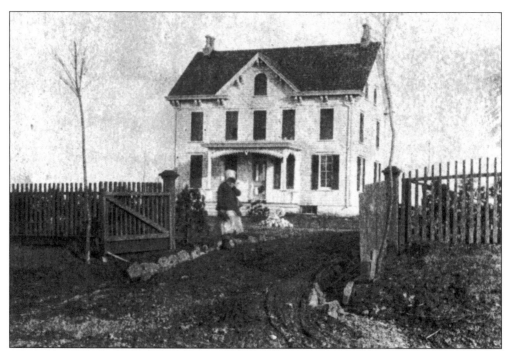

A HOME IN HOPEWELL BOROUGH. A symmetrical farmhouse in Hopewell Borough serves as the backdrop for this pre-1900 photograph of a young girl peering out from under her bonnet.

CONTENTS

Acknowledgments 6

Introduction 7

1. The Revolutionary War Era 9

2. Growth of a Rural Community 17

3. Local Homes and Churches 25

4. Developments in Transportation 45

5 People: Some Famous, Some Not 63

6 Commercial Establishments 83

7. Educational Institutions 99

8. Men in Uniform 107

9. Crossroads Communities 119

Photograph Credits and Major Works Consulted 127

ACKNOWLEDGMENTS

The Hopewell Valley, as anyone who lives here will attest to, is a wonderful place. Whether you reside in Hopewell Township, Hopewell Borough, or Pennington Borough, the entire area is home. A place of natural beauty, it is inspirational. One such inspiration was the writing of this book and, for its successful creation, we have many terrific people to thank. Thank you to everyone at Arcadia Publishing, especially our attentive editor, Peter Turco. Without the knowledge and support of members of the Hopewell Valley Historical Society (HVHS) and the Hopewell Museum, we could not have progressed. In particular, thank you to Jack Davis, Jack Koeppel, David Blackwell, Miles Ritter, Bill Schmidt, and Bob and Carol Meszaros, all of HVHS; and Beverly Weidl, Mary Palmatier, and David Mackey of the Hopewell Museum. Thank you to Marie Palsir, parish secretary and keeper of the photograph albums at St. James Church. Thank you to Karen Bannister for sharing Chris's wonderful collection. Thank you to Beth Miko and Barbara Orr of the Hopewell Borough Library. Thank you to Janet Payne. Thank you to friends Maureen Smyth, Jane Oshinksy, Gail Stern, and Debbie Gwazda of the Historical Society of Princeton. Thank you to Pete Watson, director of the Howell Living History Farm. Thank you to Michael McCue of Washington Crossing Historic Park. Thank you to Janet Six for sharing her fascinating knowledge of Webster Edgerly. Thank you to Mark Falzini, archivist of the New Jersey State Police Museum, and to Sergeant Flint of the New Jersey State Police. Thank you to Nancy Carter Ceperley, historic preservation specialist at the Johnson Ferry House. Thank you to Jean Koeppel. Thank you to Phil Hayden of the New Jersey State House. Thank you to Megan Springate and Lee Ellen Griffith of the Monmouth County Historical Association. Thank you to Bea Castoro of the St. Alphonsus parish. To our Hopewell friends, Deborah Toth and David Krauss, David and Deirdre Carroll, Christine McGarty, and Kathy Pagano, thank you for your support, company, supplies, and children-watching services. Finally, thank you to our family for their love.

INTRODUCTION

Hopewell Valley lies in the western part of central New Jersey, bordered on the west by the Delaware River. One of the largest municipalities in the state, it spans 58 square miles. Within its borders are two separate municipalities, the boroughs of Hopewell and Pennington, as well as the village of Titusville, which has never officially split off from the township.

The name Hopewell has been found in documents as far back as 1688, where it is mentioned in a land purchase made by Andrew Smith. Hopewell officially became a township in 1699. The name Hopewell is of uncertain origin. Legend has it that two farmers would call greetings to each other along the lines of "Hope you are well" and "I am well," leading to the local names Hopewell and Amwell. Other sources speculate that the name Hopewell comes from a place in England from whence early settlers came.

The area was settled in the 18th century. In those days before speedy travel, distances that today are considered small were more substantial, and villages sprang up around the township at crossroads and near sources of water. Washington Crossing began at the site of a ferry across the Delaware. Pennington began as Queenstown, at a crossroads. Hopewell Borough grew up around the Baptist congregation who settled and later built a meetinghouse there.

John Hart, a signer of the Declaration of Independence, had a farm near the Baptist meetinghouse, and George Washington planned the Battle of Monmouth at a nearby farmhouse. Washington's famous crossing of the Delaware occurred in the western end of the township, and British soldiers had an outpost in Pennington. The Hopewell Valley played a significant part in the United States of America's national birth, and this is the subject of the first chapter of *Hopewell Valley*.

The township continued to grow with the new nation in the 19th century. Roads were laid out, and new villages arose; although they were not yet separate entities, Hopewell and Pennington Boroughs saw the most rapid expansion. Titusville grew up as a river town north of Washington Crossing in the 1800s and hamlets, such as Mount Rose and Woodsville, also began to attract more settlers. Some of the crossroads communities that have come and gone in the Hopewell Valley are examined in chapter 9.

In the middle years of the 19th century, improvements in travel began to cause major changes in the township. The bridge at Washington Crossing was built in 1834, signaling the end of the ferry and making travel to and from Pennsylvania much easier. In that same year, the Delaware and Raritan Canal was completed. A feeder canal ran through Hopewell Township parallel to the Delaware River, and this canal spurred the growth of Titusville.

The most important development of the 19th century in the Hopewell Valley had to be the arrival of the railroad. The first trains went through Titusville and Washington Crossing in 1851, followed by another line that ran through the villages of Hopewell and Pennington in 1873. A third, more successful line replaced this earlier line only three years later.

The railroads changed the face of the Hopewell Valley. The hamlets that had been bypassed by the train lines began to decline, while the villages of Hopewell and Pennington experienced a boom. The two villages grew so quickly that their residents voted to withdraw from Hopewell Township and become separate municipalities. The borough of Pennington came into being in 1890; the borough of Hopewell followed suit in 1891. Chapter 4 details the developments in transportation that affected the Hopewell Valley.

With the expansion of the two boroughs and Titusville came a need for new services; chapter 6 features a selection of commercial establishments from the late 19th and early 20th centuries. Also important were the various schools that appeared throughout the township to educate children as well as young men and women; many are included in chapter 7.

With the 20th century came automobiles, electricity, telephones, and more war. Some of the men who fought in World War I are seen in chapter 8, along with soldiers from the Civil War, in which Hopewell Valley citizens played a part. The popularity of cars led to expansion of the road network, which really took off in the 1920s. Route 29 had been laid out along the Delaware River through Titusville and Washington Crossing during World War I, and Route 31 was completed in 1927.

In 1932, tragedy struck Hopewell Valley when the son of world-famous aviator Charles Lindbergh was kidnapped from the family home, located just north of the Hopewell Township border. Though Lindbergh did not live in Hopewell Township, the borough of Hopewell was the closest "downtown" and the baby's corpse was later found in the woods near Mount Rose. Newspapers across the world ran front page stories about the events in Hopewell, making this the valley's most famous event since Washington crossed the Delaware.

Since the Lindbergh trial ended, Hopewell Valley has been quiet on the world stage. Another world war came and went, followed by economic expansion fueled by cars and more roads. The second half of the 20th century saw the population of the township continue to grow as farming declined. The rural character of the community remains in many places, however, and echoes of its past can be seen in chapter 2.

Today, the Hopewell Valley remains a place of contradictions, from the Sourland Mountains in the northeastern section to the lowlands by the Delaware, from the farms that remain to the heavily developed area south of Pennington. Many of the people who inhabited the valley in years past can be seen in chapter 5, and some of their homes appear in chapter 4, along with many of the churches that have guided the spiritual lives of the community.

This photographic history of the Hopewell Valley owes much to two men who worked hard to document and preserve its images. One was George Hart Frisbie, whose photographs make up the Frisbie collection of the Hopewell Valley Historical Society. The other was Christopher Bannister, who spent many years working to preserve and reproduce historical photographs for the Hopewell Museum, the Hopewell Valley Historical Society, and local authors. Together, they were responsible for many of the photographs that make up this book.

One

THE REVOLUTIONARY
WAR ERA

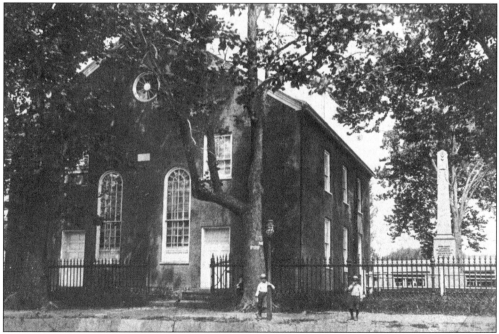

THE JOHN HART MONUMENT. Rising above the gravestones in the cemetery adjacent to the Old School Baptist Church in Hopewell Borough is the Hart Monument. Dedicated to John Hart, Hopewell's own signer of the Declaration of Independence, the monument was unveiled on July 4, 1865, in a ceremony attended by the governor. This marks the first memorial monument erected by the state of New Jersey.

JOHN HART'S SIGNATURE. A gentleman farmer with little formal education, John Hart was born in 1713, lived his entire life in Hopewell Valley, and was known for composing excellent letters. He purchased his "homestead plantation" near the Baptist meetinghouse, where he lived with his wife, Deborah, from *c.* 1757 until his death in May 1779. Although appointed by King George to serve as a judge in 1768, Hart became a leader of the growing rebellion. He was vice president of the New Jersey Provincial Congress and in June 1776, he was elected with four others to represent the colony of New Jersey in the Continental Congress. Soon after, all five representatives signed the Declaration of Independence. A recognized leader in his day, Hart was unanimously chosen as the first Speaker of the New Jersey Assembly. The Hart house, which was located on what is now Hart Avenue in Hopewell Borough, continued as a dwelling until 1805, when it was taken down by Thomas Phillips and replaced by the brick and stone residence that still stands.

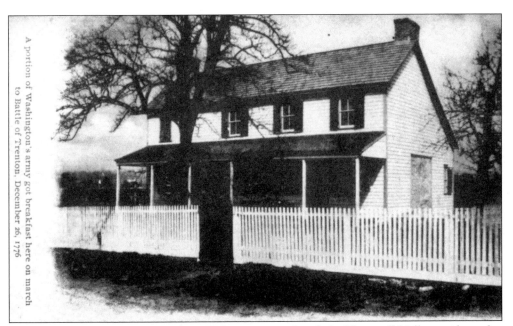

THE OLD SWAN HOTEL. December 1776 was a time of strife for Hopewell Valley residents due to the presence of British and Hessian soldiers. Having chased Gen. George Washington and his troops into Pennsylvania, the Hessians set up camp in Trenton, with a British outpost in Pennington. Pictured is the Swan Hotel, the 19th-century version of the tavern that was in operation by the 1760s and used by British General Cornwallis in 1776.

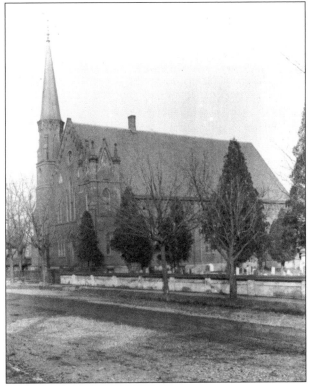

THE PENNINGTON PRESBYTERIAN CHURCH WALL. When the British and Hessian soldiers arrived in Pennington late in 1776, they took possession of the Presbyterian church, the largest building in town. The troops forced out the minister, destroyed church records, and turned the building into a barracks. They used the pews to chop meat, broke the marble top of the communion table, and used the churchyard brick wall to exercise their horses.

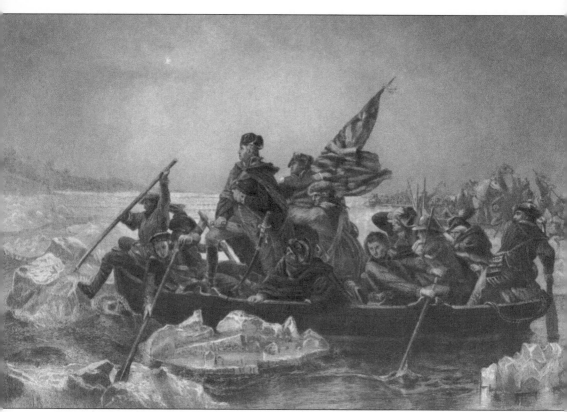

WASHINGTON CROSSING THE DELAWARE. Imagine leading an army of men as you are chased out of New York, across New Jersey, and into Pennsylvania. The British are hot on your heels, morale is low, and harsh winter weather has set in. In an effort to turn the tide of the war, you decide to cross troops and artillery from the Pennsylvania side of the Delaware River to the Hopewell Valley shores, putting you 8 miles or so upriver from where the enemy troops are camped at Trenton. From here you will march through the night and surprise the enemy. This is the wise decision George Washington made, captured so well by Emanuel Leutze in his 1851 painting. Look closely and you can see the front man in the Durham boat battling the jagged ice of the river. What you cannot see is a sleet storm raging, a fierce wind blowing, swift currents churning, and men from Hopewell Township waiting on shore to help unload the boats. The painting was the inspiration for this 1850s engraving by J. Rogers.

THE RIVER BANK WHERE CONTINENTAL TROOPS LANDED. As Durham boats made their way across the Delaware on December 25, 1776, they landed on these shores of "Eight Mile Ferry," a reference to the distance upstream from Trenton. Washington Crossing State Park is part of the area now known as the Washington Crossing section of Hopewell Township. The park was designated as a National Historic Landmark in 1935.

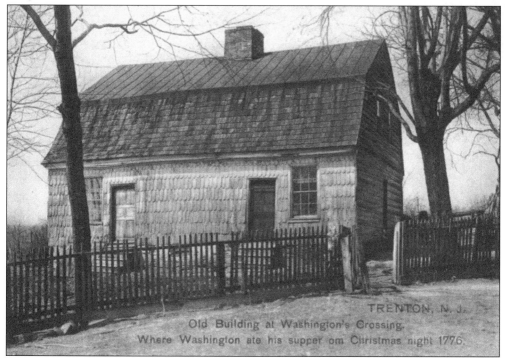

WHERE WASHINGTON ATE SUPPER ON CHRISTMAS NIGHT, 1776. Having crossed the icy Delaware, Washington waited on the Hopewell Valley side for the other crossings to be completed. Between late afternoon when he landed and the 4:00 a.m. form-up of his troops, the general ate a Christmas night meal at this house. He may have shared this meal with Capt. Alexander Hamilton and young Lt. James Monroe, both of whom were present.

13

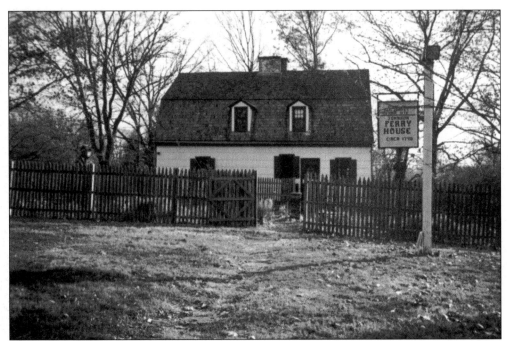

JOHNSON'S FERRY. Before a bridge spanned the Delaware River near the site where Washington crossed, there was a large plantation on the Hopewell Valley side. Owner Rut Johnson held a tavern license, and James Slack ran a ferry service. Continental army officers probably used the ferry house during the night of the crossing. The house stands today within Washington Crossing State Park and is open to the public.

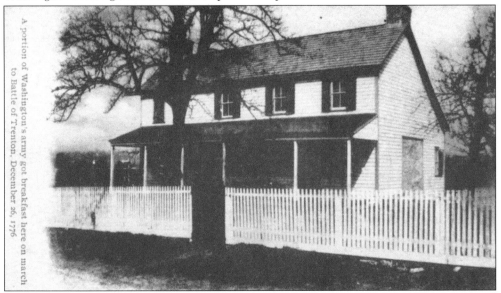

A portion of Washington's army got breakfast here on march to Battle of Trenton, December 26, 1776

OLD BEAR TAVERN. When planning his surprise attack on Trenton, Washington had expected his troops to be marching by midnight and reaching the city by dawn. Because weather conditions were so harsh, they were four hours behind schedule. The troops marched east to Bear Tavern, a crossroads community established in the mid-18th century around this tavern. It was here that a portion of the Continental army had breakfast.

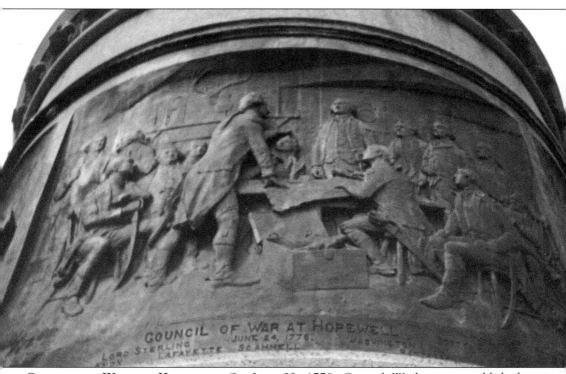

COUNCIL OF WAR AT HOPEWELL. On June 23, 1778, General Washington established headquarters at the Hunt House, where the next day he, Lafayette, and other officers held a council of war to plan the Battle of Monmouth. Awaiting orders were 12,000 soldiers encamped on the hill between Van Dyke Road and Hopewell-Wertsville Road, north of Hopewell Borough. The army resumed its march east toward Rocky Hill the next day. Pictured is one of five bronze plaques depicted on the 100-foot granite Battle of Monmouth Monument in Freehold. Commissioned by the Monmouth Battle Monument Association, the monument's cornerstone was laid on June 28, 1878, exactly 100 years to the day from the battle, and unveiled on November 13, 1884. The *Council of War at Hopewell* bas-relief was designed by New York City sculptor James Edward Kelly and cast at the National Fine Arts Foundry in New York City. The scene joins four others that encircle the monument.

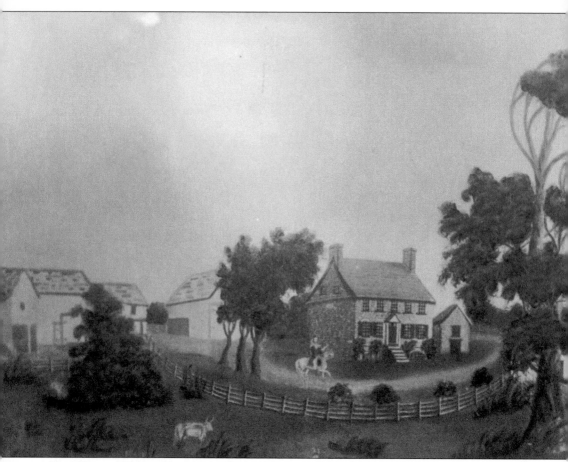

THE HUNT HOUSE. Famous as the strategic meeting place of George Washington and his officers in June 1778, the house takes its name from John Price Hunt, who resided there at the time of the council of war. The house was built and owned by Col. Joseph Stout, a relative of Hunt. By 1851, the Weart family owned the house and planned to do extensive renovations. So that the family could have a picture of their beloved "Hilltop," as they called the house, Elizabeth Boggs sketched it for them. The original sketch was colored by hand and is on display at the Hopewell Museum in Hopewell Borough. Interestingly, the artist is the same Elizabeth Boggs who, with her sister Mary Boggs, established the Female Seminary in Hopewell in the mid-1860s. The house still stands today north of Route 518 on Province Line Road.

Two
GROWTH OF A RURAL COMMUNITY

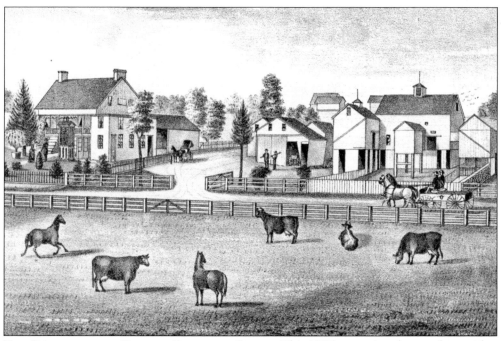

THE RESIDENCE AND FARM OF RANDOLPH STOUT. This 1875 engraving shows a farm with a large farmhouse and numerous outbuildings. Located on Hopewell-Amwell Road, this farmstead still stands, though the farmhouse was long ago demolished. Randolph Stout lived here until 1877, when he and his wife built a home on East Broad Street in the village of Hopewell. That home is now the Hopewell Museum.

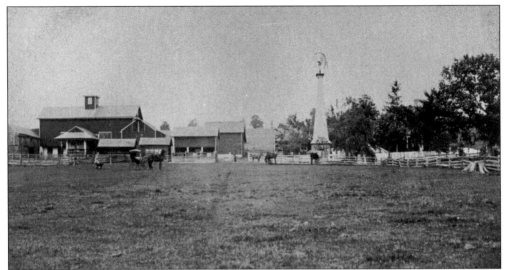

THE HOMESTEAD FARM OF DAVID VOORHEES. On Van Dyke Road, just off the Pennington-Hopewell Road, sat this farm, shown here as it appeared *c.* 1890. It had been owned by a miller named James Hunt. Legend has it that the only British troops captured in Hopewell Valley during the American Revolution were apprehended on this farm.

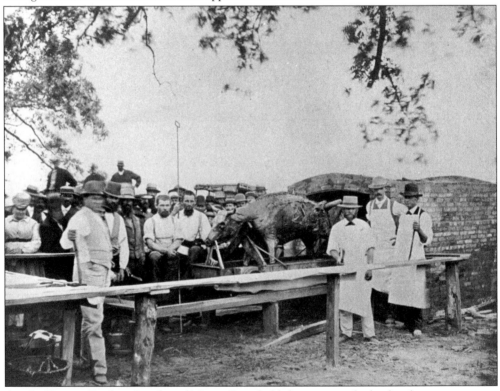

AN OX ROAST. Reuben Savidge of Mount Rose held this ox roast for his loyal customers some 100 years ago. He sold fertilizer, among other items, and competition for business was fierce. Savidge sold the Lister Brothers brand, and this was a promotional stunt to reward those who bought his goods on a regular basis.

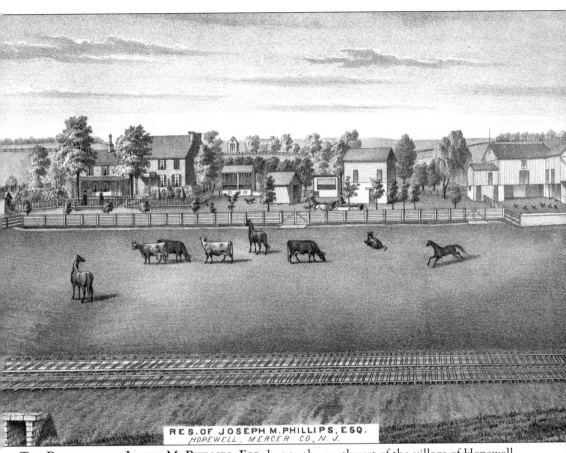

RES. OF JOSEPH M. PHILLIPS, ESQ.
HOPEWELL, MERCER CO., N. J.

THE RESIDENCE OF JOSEPH M. PHILLIPS, ESQ. Just to the northwest of the village of Hopewell in 1875 lay the residence and farm of Joseph M. Phillips. This engraving shows the farmhouse on the left, with two women standing in front of it. Several outbuildings are to the right of the house, including what appears to be a henhouse. Horses and cattle share a pasture in front, and beyond them pass two sets of railroad tracks, likely belonging to the old Mercer and Somerset line, since the Delaware and Bound Brook line had not been completed in 1875. This farm had belonged to John Hart in the 18th century and had changed little in the ensuing years. Thomas Phillips bought it at a sheriff's sale in 1785, and only 22 acres had been removed by the time of this picture. This and all of the other farms in Hopewell Valley could be traced all the way back to Daniel Coxe, original owner of the 30,000-acre tract that was to become Hopewell Township.

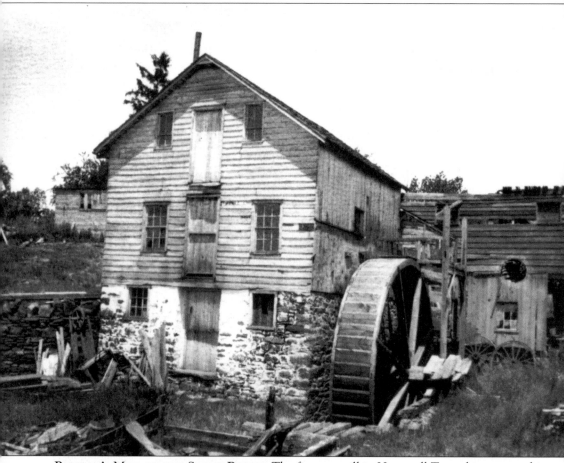

RUNYAN'S MILL ON THE STONY BROOK. The first sawmill in Hopewell Township appeared in the late 1700s and by the early 19th century, there were six sawmills in operation in the Hopewell Valley. Like the one shown in this photograph, they were water driven. This waterwheel was used to run a large saw that cut local trees into usable lumber. As timber was cleared for settlement in the 1700s, the need for sawmills increased. Large mills, located on larger waterways in the township, often milled other products as well, such as grain. By the early 20th century, however, the timber stock in the Hopewell Valley had declined, and with it went the sawmills. The locations also shifted, as railroads replaced waterways as the main routes for transporting goods. By the early 20th century, all of Hopewell's mills had shut down, victims of changing times. Only the Somerset Roller Mills still stand today, though ruins of other mills may be found by the determined seeker.

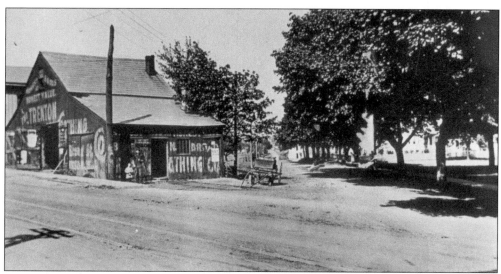

THE EGE BLACKSMITH SHOP. A trade that has almost disappeared from the landscape of the Hopewell Valley is that of the blacksmith. In 1910, however, around the time of this photograph, the "mighty village smithy" was necessary to shoe the horses used in the farm community, among other tasks. The Hopewell Presbyterian Church now stands at this location, which has become the busy intersection of West Broad Street and Louellen Avenue.

CAMPING BY THE DELAWARE. A Pennington family, believed to be the Wileys, shares a tent as they camp out in Titusville along the eastern shore of the Delaware in 1899. Though the tent suggests a vacation and the bicycle on the left was probably ridden for pleasure, this hardy group's formal attire shows the relatively strict mood that prevailed, even on a family outing.

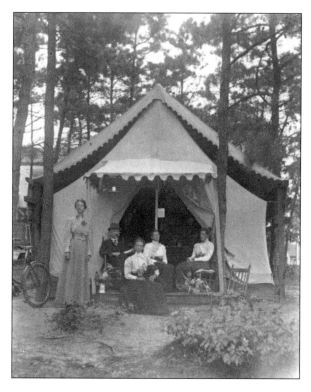

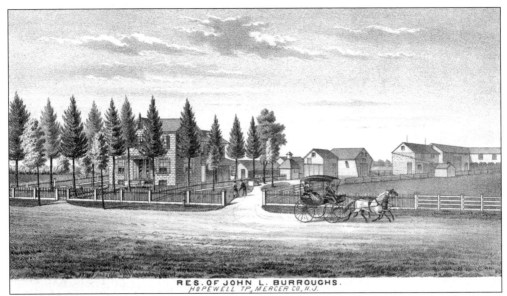

RES. OF JOHN L. BURROUGHS.
HOPEWELL TP, MERCER CO, N.J.

THE RESIDENCE OF JOHN L. BURROUGHS. This pretty farmstead is located in the north-central part of Hopewell on Marshalls Corner-Woodsville Road, midway between those two villages. This farm is now the site of a housing development, yet the old farmhouse remains, though substantially modernized. The buildings in this engraving were probably erected in the late 18th or early 19th century.

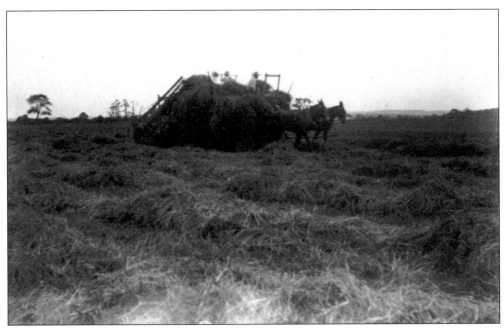

BALDWIN'S HAY FIELD. Horses pull a wagon as farmers gather hay in this bucolic scene c. 1900. Records show that this farm was south of Pennington Borough on the Pennington-Lawrenceville Road. Some farmers referred to this type of wagon as a "mankiller," due to the chain underneath it that gathered the hay. This apparatus relieved farmers of the need to pitch the hay into the wagon with forks.

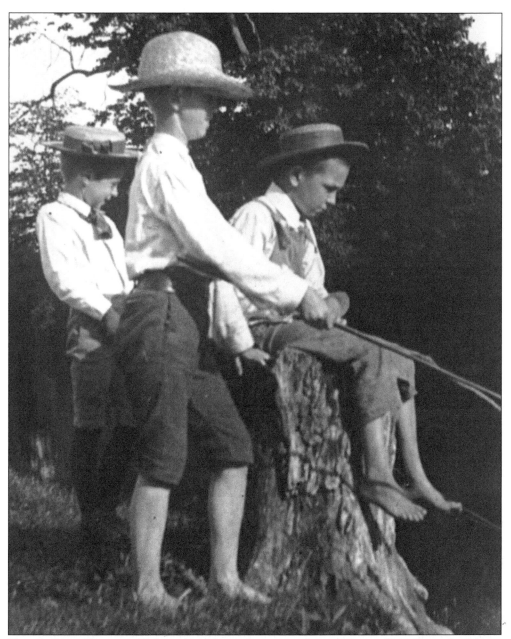

THREE BOYS FISHING. Fishing has always been popular in Hopewell Valley, whether in knickers or in wading boots. These three boys are identified only as Edgar, Ray, and Lewis, and this photograph dates from 1900. The two older boys on the right are seriously pondering their lines, while the younger boy seems to be enjoying their efforts. One of these boys is almost certainly Edgar Frisbie, son of amateur photographer George Frisbie, who took this picture. Edgar was born in 1893 and was either six or seven years old when this photograph was taken. Life was not always so carefree for young Edgar, unfortunately. He joined the armed forces in World War I and died of pneumonia in France near the end of the conflict. Perhaps, while fighting in the trenches, he was able to think back to his childhood in Pennington, when his biggest problem involved getting a nibble at the end of his line.

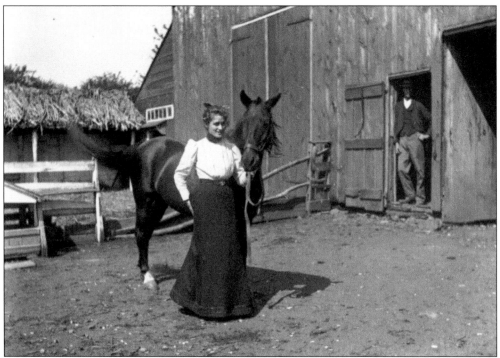

ANNA SKILLMAN. In this photograph, *c.* 1899, Anna B. Skillman shares a light moment with her horse, while an unidentified man, possibly a farmhand, looks on. She attended the Emerson College of Oratory in Boston and returned between terms to the home of her parents, Mr. and Mrs. Elias Skillman. Their farm was just south of Pennington Borough.

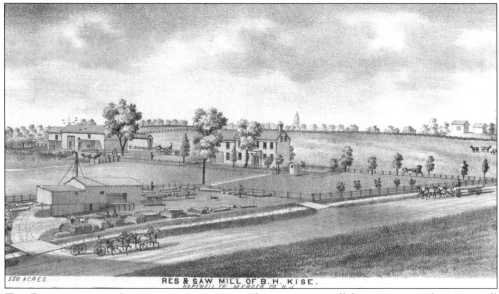

THE RESIDENCE AND SAWMILL OF B.H. KISE. This steam sawmill first appears in the Hopewell Township record books in 1870. It featured a gate saw and a circular saw and made lumber from oak, hickory, and ash trees. Located on the west side of Hopewell-Wertsville Road, south of Featherbed lane, the mill is shown as it appeared in 1875. Nothing remains standing today.

Three

LOCAL HOMES AND CHURCHES

THE BUNN HOMESTEAD. Some 2 miles north of Pennington on Yard Road is the site where Jonathan Bunn's home once stood. Built before 1750, the house was the site of the first Methodist meetings in the area. The Methodists stopped using this house when they took over the former Presbyterian church in 1776. They later built their own church in Pennington in 1826. This historic house was torn down in 1949.

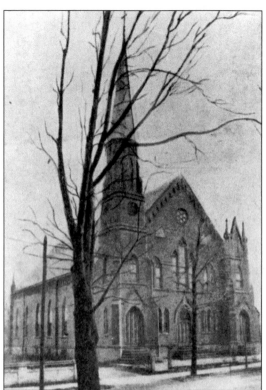

THE PRESBYTERIAN CHURCH IN 1921. Local Presbyterians first began to worship in nearby Maidenhead in 1709. A frame church was built in Pennington in 1724 and was replaced by another structure in 1765. This, too, was remodeled in 1830, only to be replaced in 1847 and again in 1875, after the fire.

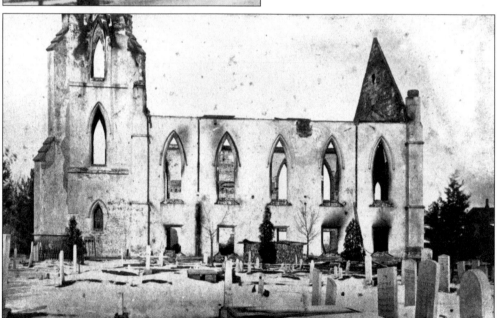

THE PRESBYTERIAN CHURCH AFTER THE FIRE OF 1874. On January 25, 1874, just after Sunday morning services ended, fire broke out. Despite the best efforts of parishioners to douse the fire with buckets of water, the church burned in less than an hour. The congregation resolved to replace the building as soon as possible and in 1875, the new church was erected. It still stands today.

THE FIRST BAPTIST CHURCH OF PENNINGTON. Originally knows as the Pennington African Baptist Church, this organization formed in 1902 and bought this building on Academy Street to use as a church in 1904. Constructed in 1857, the building was used as the town's public school until 1900. After being moved across the street, it became an athletic club and then the church, which it remains today.

THE SITE OF THE EARLY METHODIST CHURCH. The house on the right, located at 145 South Main Street in Pennington, was built in 1826 when the old Methodist Church was becoming run-down. The building cost $1,516.92 and served the congregation for 19 years, until the present church was constructed in 1845. The church that was in use before 1826 was known as the Old Red Church and, before being torn down, was located at the site of the cemetery on Pennington-Titusville Road.

27

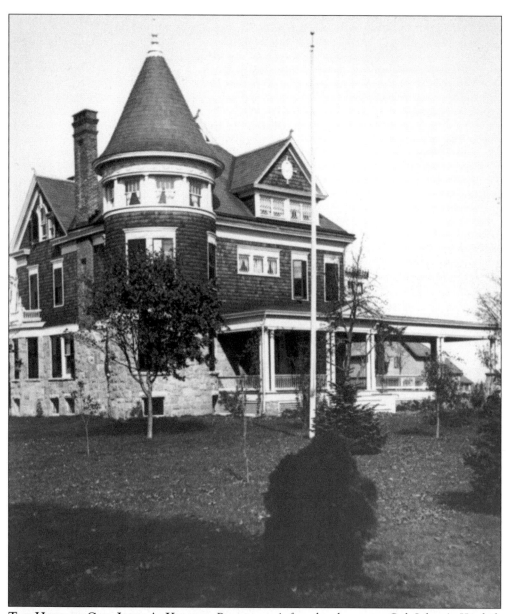

THE HOME OF COL. JOHN A. KUNKEL. Pennington's first developer was Col. John A. Kunkel, who arrived in the newly independent borough from New York in 1894. The following year he built Stony Brook Lodge, his home, on East Delaware Avenue. Kunkel led a colorful life. He served the Union in the Civil War and was a personal guard to Abraham Lincoln as the President journeyed to his first inauguration. Kunkel left his Pennsylvania birthplace to become a merchant in New York before moving to Pennington. Over the next three decades, Kunkel was responsible for planning and developing Eglantine Avenue and King George Road. He promoted the idea of removing fences from around homes, insisting that they marred the beauty of the landscape. He offered lots of 50 feet by 270 feet on Eglantine Avenue for $150 to $350 each; lots 100 feet by 200 feet on King George Road were sold for $200. Kunkel was one of the business leaders of his day who was responsible for much of the residential and commercial development that helped Pennington Borough grow.

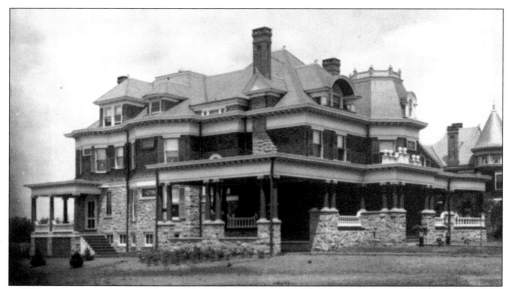

THE ANNA S. SMITH HOUSE, PENNINGTON. Built *c.* 1900, this ornate Queen Anne-style home is located at 115 East Delaware Avenue. Known as Duquesne Manor, it was the residence of the wealthy Anna S. Smith, whose friend Col. John Kunkel lived next door in Stony Brook Lodge. The massive Duquesne Manor features an elaborate gallery porch and a beautiful stained-glass window. The home was later converted to the rectory of St. James Roman Catholic Church.

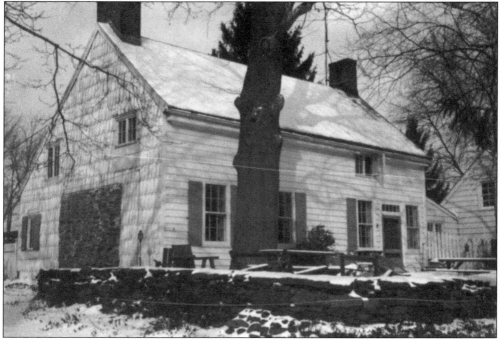

THE MOORE FAMILY HOUSE, PENNINGTON. Records show that there were 138 homes in Hopewell Township by 1722, but it is not clear whether this old house was among them. It was known to be the property of the Moore family in the 1700s. Mud, hair, straw, and stones were used in place of plaster, and the house still stands today on Curlis Avenue.

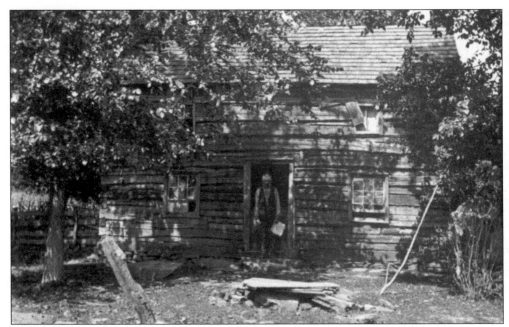

HILLMAN'S LOG HOUSE. Christopher Hillman stands in the doorway of his log house on Mountain Church Road. Born in Germany in the 1820s, he had emigrated to the United States by 1854. When he arrived in the Hopewell Valley, most of the good land was spoken for, and families such as his chose to settle in the Sourland Mountains, where the soil was rockier and farming more arduous.

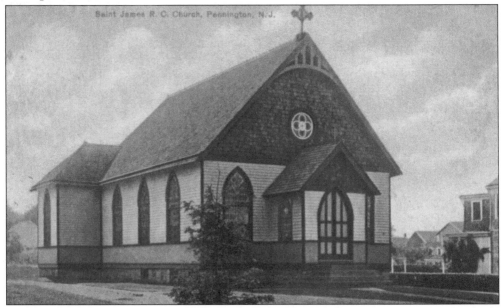

ST. JAMES ROMAN CATHOLIC CHURCH. Irish immigrants new to America were hired to build the Mercer and Somerset Railroad; they settled west of Pennington on what is today called Dublin Road. They first attended mass in Trenton and then at St. Alphonsus Church in the village of Hopewell, after that church was built in 1878. Finally, in 1899, St. James Church was built in Pennington, making regular attendance at services much easier for these hardy souls.

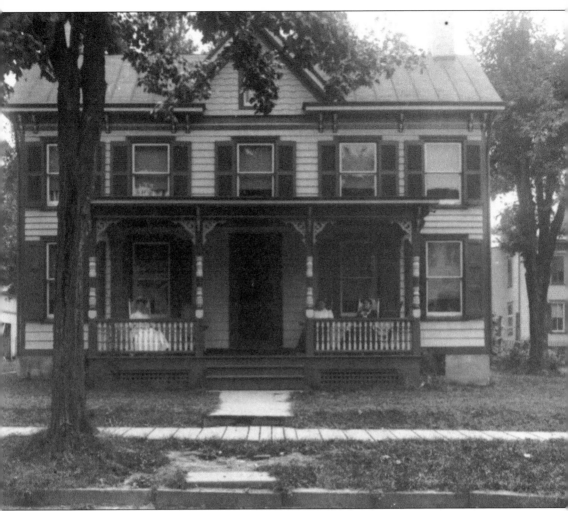

THE FRISBIE FAMILY HOME. Born in Pennington in 1852, George Hart Frisbie took over his family's grocery business at 44 South Main Street in 1881 and several years later went to work for J.H. Blackwell and Sons, a wholesale grocer in Trenton. Frisbie was also an amateur photographer, who took pictures in and around Pennington to document the people, places, and events occurring around the end of the 19th century and the beginning of the 20th century. Though rolls of film had become popular in the 1890s, leading to an explosion of interest in photography, Frisbie continued to use the traditional glass plate method, which produced negatives that have survived more than 100 years. Many of his photographs were used in compiling this book, and the collection of more than 600 negatives is currently held by the Hopewell Valley Historical Society. The collection was donated in 1986 by the late Alice Frisbie, whose father-in-law, Walter Frisbie, was the photographer's brother and the mayor of Pennington during World War I.

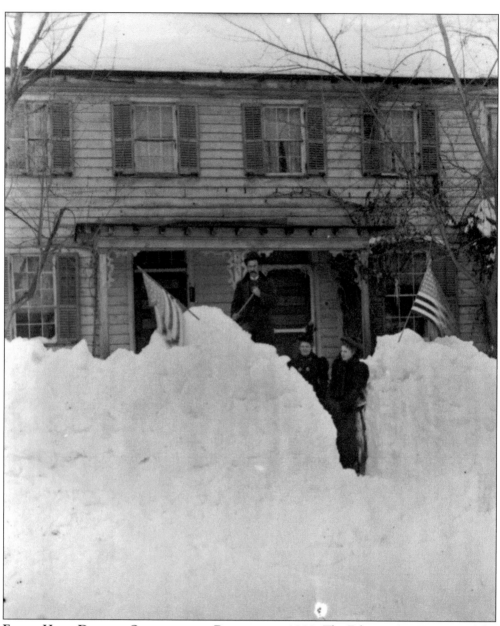

Frank Hart Digging Out from the Blizzard of 1899. The February 2, 1898 issue of the *Hopewell Herald* features a small advertisement for Dr. Frank T. Hart, dentist of Pennington. Hart specialized in painless extraction. He also appears to have specialized in snow removal. During the week of February 6, 1899, the weather was terrible. A *Herald* article reports that "Monday last was the most disagreeable day that we have ever experienced with snow and blow, and the night was even worse than the day. It was really dangerous to be out in the evening. The next morning, Hopewell and Pennington boroughs saw snowdrifts four feet deep on porches; streets and sidewalks were nearly impassable. Everyone pulled together to shovel, and by four o'clock in the afternoon travel was again possible." The newspaper added that country roads were worse than they had been since the Blizzard of 1888, which went down in Hopewell Valley history as one of the worst ever.

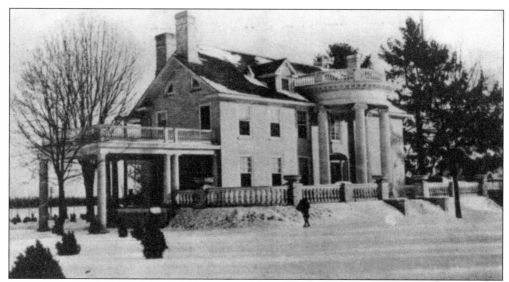

THE RESIDENCE OF MAYOR WILLIAM P. HOWE SR. Pictured in 1913 is the magnificent home of Mayor William P. Howe, located at 65 South Main Street in Pennington. Earlier known as the Fish farmhouse, this building was extensively renovated and renamed "Dixie." The neo-Georgian-style home survives today as a professional building. Howe moved out around the time of this photograph and into the old Sked farmhouse, also on South Main Street.

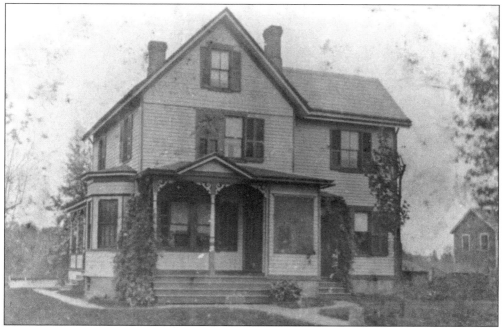

THE RESIDENCE OF T.D. DURLING. This photograph, taken c. 1900, shows the home of T.D. Durling, a prominent citizen of Pennington at the time. It stood at 8 West Franklin Avenue. This portion of the street was laid out in 1875 and was christened Franklin Avenue when Benjamin Franklin Lewis built a house there.

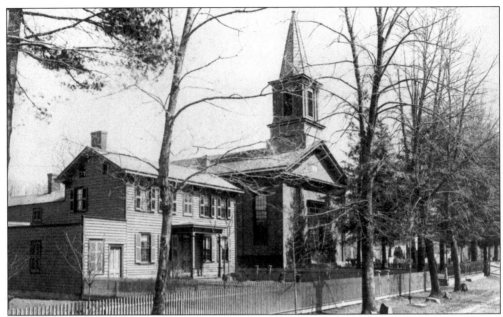

THE TITUSVILLE PRESBYTERIAN CHURCH. The Presbyterian community in Hopewell Township had grown sufficiently by the 1830s to support a second church, located in the western end of the township in the village of Titusville. The church pictured here was constructed in 1855, replacing the original stone meetinghouse that had been built on River Drive less than 20 years before. The church remains in use today.

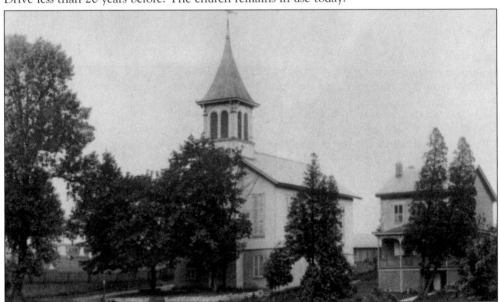

THE TITUSVILLE METHODIST EPISCOPAL CHURCH. In 1828, the village of Titusville saw its first church built when the Methodist congregation, which had organized in 1805, constructed the River Methodist Episcopal Church on Church Road. The church was demolished 38 years later and was replaced with the larger church shown here. The two-story frame building continues to serve the community, and a new cemetery has replaced the old graveyard next to the church.

34

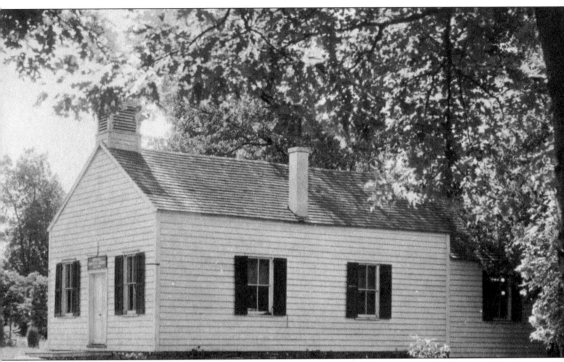

THE MOUNTAIN CHRISTIAN CHURCH. Before the Civil War, there were four varieties of Christian church in the Hopewell Valley. Presbyterians, Baptists, and Methodists had all become established in the 18th century, and each denomination had more than one church in different parts of the township. The fourth variety to arrive was the so-called Christian Church, an ancestor of the later Fundamentalist movement. Located in the Sourland Mountains, the Hopewell Mountain Christian Church served the rural mountain community. The building was a simple frame structure with one large room and a small bell in a cupola above the door. It was built in 1844 to house the congregation, which had first organized in 1828. Services were held for the first 16 years in a building nearby that later became the Tidd School, serving the children in the northernmost part of Hopewell Township. Land was then given to the congregation by John Horn, and this church was built. Though now used as a residence, the church remained open for services into the 1980s, and members who attended still live in the surrounding area.

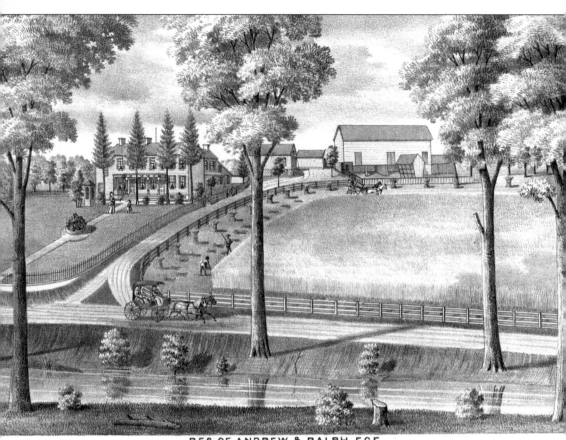

RES. OF ANDREW & RALPH EGE.
HOPEWELL TP, MERCER CO, N.J.

THE RESIDENCE OF ANDREW AND RALPH EGE. This engraving, found in the *1875 Combination Atlas Map of Mercer County*, portrays the Ege farmstead in Hopewell Township. Ralph Ege was one of the area's first historians, writing a series of 35 articles beginning in May 1901 for the *Hopewell Herald*, the Hopewell Borough newspaper. Those articles, along with 13 more, detailed the people and events of the Hopewell Valley from its founding in the late 1600s through the American Revolution and up to the 20th century. The entire collection of articles was published in a volume entitled *Pioneers of Old Hopewell* in 1908; a 1963 reprint edition can still be purchased at the Hopewell Museum. As this etching of life in Hopewell Township 125 years ago demonstrates, the Ege family were farmers, living outside the growing villages, where the recent arrival of trains was causing rapid development. The horse and buggy was still the best way to get to town, and hay was mown by hand.

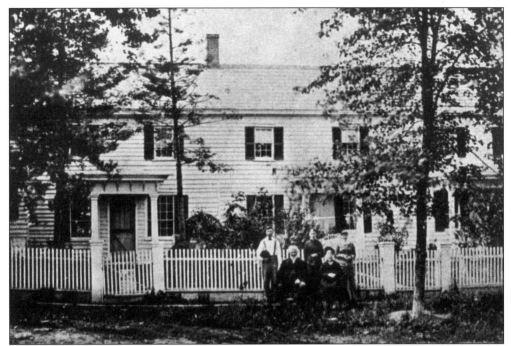

THE STEPHEN BLACKWELL FAMILY AND HOME. This house was situated at 42 East Broad Street in Hopewell Borough and is shown as it appeared *c.* 1880. Seated is Stephen Blackwell, who ran a successful store in the village in the early 19th century and died in 1883. The building had been one of the historical treasures of Hopewell until it was torn down in 1987.

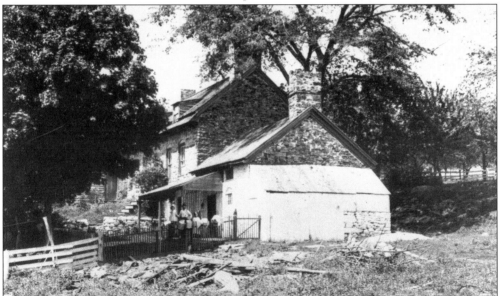

THE SMITH/HUNT/HILL FARMHOUSE. Probably built by Wilson Hunt in the first half of the 18th century, this stone farmhouse is found on Marshalls Corner-Woodsville Road in Hopewell Township. The house includes three sections: two are built along the lines of the traditional bank house, into the bank of a hillside; the third is a kitchen. The overall style of the house is German, but Dutch influences are seen in the framing.

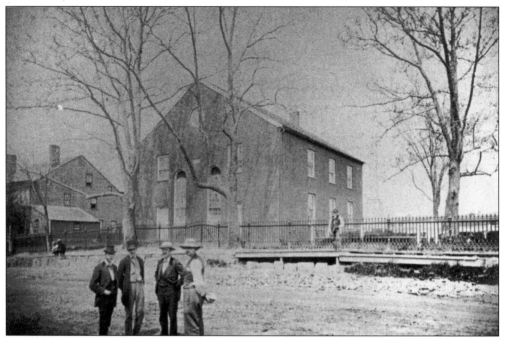

THE OLD SCHOOL BAPTIST CHURCH. The Baptist Meetinghouse on West Broad Street in today's Hopewell Borough was a center for Baptists for many miles around throughout the 18th and 19th centuries. Constructed in 1822, the building still stands. This photograph was taken sometime after the 1865 erection of the John Hart monument in the graveyard to the right.

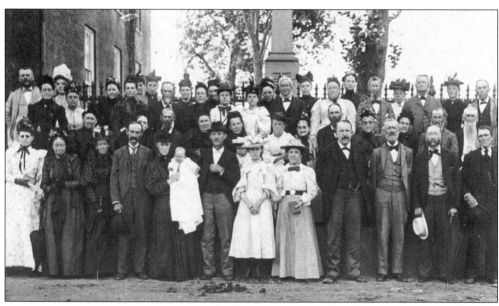

THE SATURDAY AFTERNOON CONGREGATION. The Saturday afternoon congregation of the Old School Baptist Church stands, *c.* 1893, in front of the monument to John Hart, which had been erected almost 30 years earlier. The congregation organized in 1715, and services were held at a Stout family home until 1747, when the meetinghouse was built. The Second Baptist Church of Hopewell followed in 1803, in the village of Harbourton.

THE CALVARY BAPTIST CHURCH.
Organized in 1871, this was the second Baptist church to be built in the village of Hopewell. Construction was completed by the end of 1872, and the church stands just a short distance from the Old School Baptist Church, on the other side of Broad Street, east of Greenwood Avenue. Unlike the old church, the Calvary Baptist Church remains in use today for Sunday services.

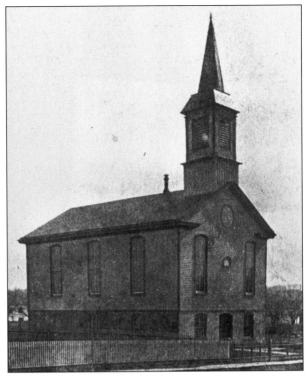

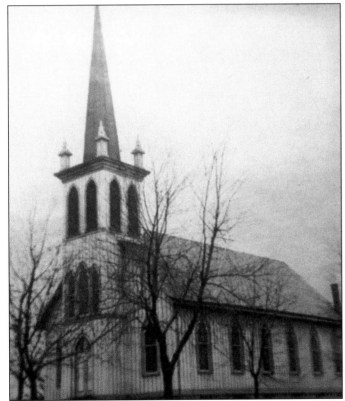

ST. ALPHONSUS ROMAN CATHOLIC CHURCH, 1882. The first Catholic Masses in northern Hopewell Township took place in 1874, when Fr. Thomas Moran of Princeton came twice a year to celebrate in the Reardon home on Province Line Road. Father Moran began to raise money to build a church in 1876, and in the summer of 1877, St. Alphonsus was built in the village of Hopewell. It has served Catholics in the area for well over a century and is still in use daily.

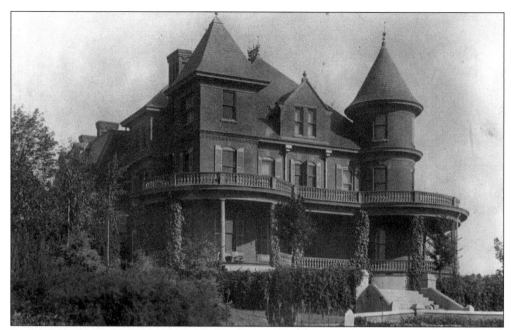

EDGERLY'S TERRACED MANSION, C. 1904. Located near the northern boundary of Hopewell Borough is this architectural curiosity. Built at the beginning of the 20th century by Webster Edgerly, this mansion was to be the first structure in a proposed utopian community called Ralston Heights. Edgerly's dream of utopia was never realized, but the building remains, tucked away on a hill overlooking Hart Avenue.

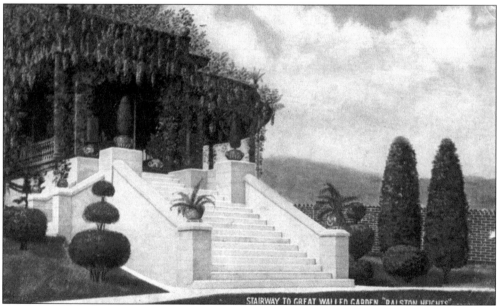

THE STAIRWAY TO THE WALLED GARDEN AT EDGERLY'S TERRACED MANSION. This postcard view of the elaborate gardens at Edgerly's mansion was taken in the early years of the 20th century. Webster Edgerly issued a pamphlet describing the proposed community as a "land for fruits, flowers, pure air, pure water, health, home and happiness." The sought-after buyers never came, and Edgerly left Hopewell in the 1920s and died soon thereafter.

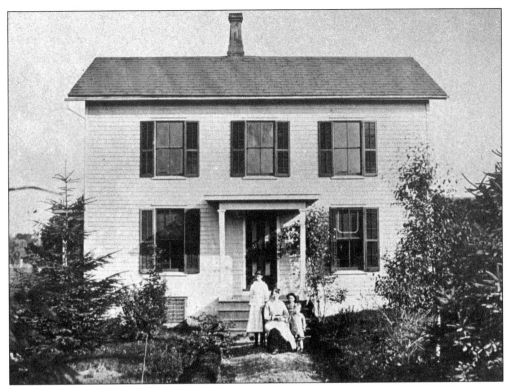

A HOME ON MODEL AVENUE. This home in Hopewell Borough is located on Model Avenue, a small street connecting Louellen Street with North Greenwood Avenue. Before it was a street, it was the railroad bed of the ill-fated Mercer and Somerset Railroad line, which had its Hopewell village station at what is now the intersection of Mercer Street and Model Avenue.

THE RESIDENCE AND STORE OF MASON EGE. This photograph shows the home and store of Mason Ege, c. 1885. Ege, whose father, Augustus Ege, was one of the first sheriffs in Mercer County, opened this hardware store on Broad Street in the village of Hopewell and it continued as a hardware store well into the 20th century. The Ege family also owned a hotel and store in the village of Woodsville.

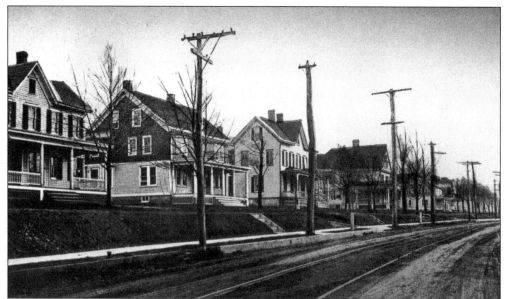

WEST BROAD STREET, HOPEWELL BOROUGH. Shown in 1920, West Broad Street leads out of the borough of Hopewell toward Marshalls Corner. These houses were all built just before or at the beginning of the 20th century, and the early telephone poles demonstrate the first inroads of that brand-new instrument. The trolley tracks seen in the middle of the street led to Pennington and then to Trenton.

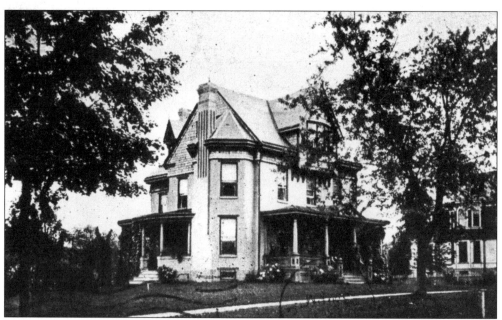

THE NELSON D. BLACKWELL HOUSE. This postcard view dating from the early years of the 20th century shows the home of Nelson Blackwell on East Broad Street in Hopewell Borough. Built c. 1860, this is probably the first professionally designed house in the borough. Blackwell was the postmaster and a dry goods merchant in Hopewell for almost 50 years, having taken over the store from his father, Stephen Blackwell.

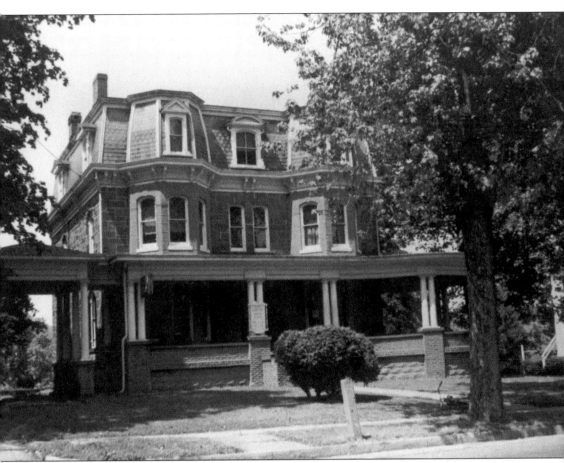

THE HOPEWELL MUSEUM. The Hopewell Museum, shown as it appeared in the mid-1920s, has long been the repository for historical information in Hopewell Borough. The museum began as the Hopewell Free Public Library and Museum Funding and Building Association, when it was incorporated in 1922. It was formed to raise funds for a building to house Sarah D. Stout's collection of antiques, which she offered to the community. The association first purchased the red brick bank building that now houses Hopewell Borough's library, but it didn't last long at that site, selling it in 1924 to purchase the former Randolph Stout residence on East Broad Street, where it continues to thrive. By 1965, the museum and the library each needed more space and the library moved to its present location. Two years later, the museum building gained a two-story addition, enabling it to display treasures garnered from local homes and a fine collection of Native American crafts. The museum is a must for anyone who wants to learn more about the borough of Hopewell and its past.

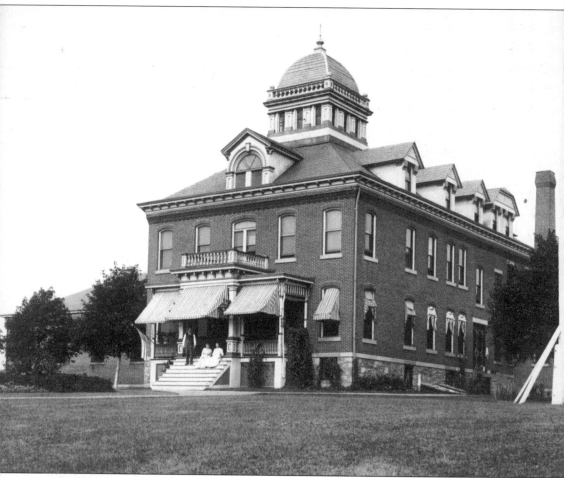

The Mercer County Workhouse. Inmates were incarcerated at this workhouse, located on Route 29 just north of Titusville in Hopewell Township. This photograph, taken in the early 1900s, shows the original building that was constructed beginning in 1892. The third county workhouse in New Jersey, it was originally built to operate under the Quaker theory that hard labor was important in the rehabilitation of criminals. The workhouse was to provide a home for criminals sentenced in Mercer County, and several buildings were added over its first three decades of existence. It also included a farm, stores, and a rock quarry, where prisoners were used to dig and crush stone for raw materials to build county roads. The workhouse is still used to house county prisoners; the quarry pit and huge stone-crushing apparatus were long ago abandoned and sit along Route 29 in disrepair. The workhouse has recently been targeted as the center of a potential historic district.

Four

DEVELOPMENTS IN TRANSPORTATION

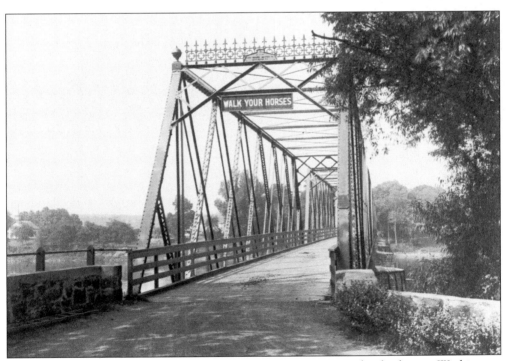

THE WASHINGTON CROSSING BRIDGE. Persons passing over the bridge at Washington Crossing were advised to walk their horses, presumably owing to the narrowness of the walkway and the possibility of falling over the side and into the Delaware River below. Horses were the earliest means of transportation available in the Hopewell Valley, and their passage over this iron truss bridge was surely a daily occurrence.

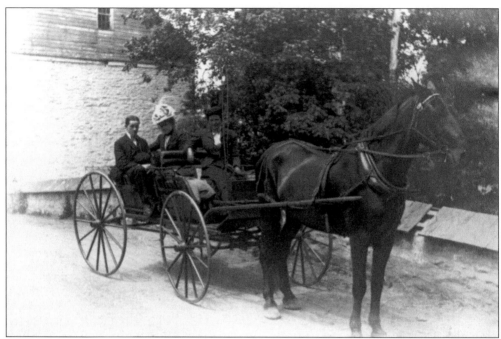

A Horse and Open Carriage. This fine horse, pictured on what is most likely a street in Pennington *c.* 1900, awaits a command to pull an open carriage, in which three persons sit in questionable comfort. As the 20th century dawned, the streets of Pennington were doubtless filled with horses—some pulling carriages, others conveying riders on their backs, and still others pulling carts with wares for sale.

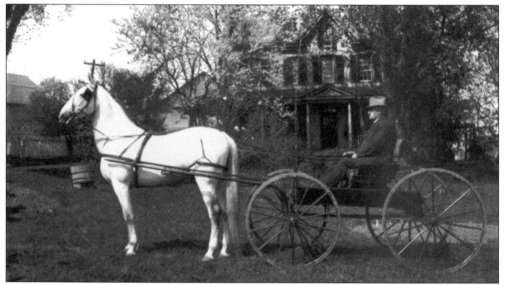

Harry Baldwin with His Bay Horse. Harry Baldwin was a horse dealer in Hopewell Township for 25 years. He bought horses in Western Pennsylvania and Illinois and had them shipped by train back to the Pennington area to sell. Ironically, a horseless carriage was the end of him: in 1921, a car he was driving got caught in a set of trolley tracks and flipped over, resulting in his death.

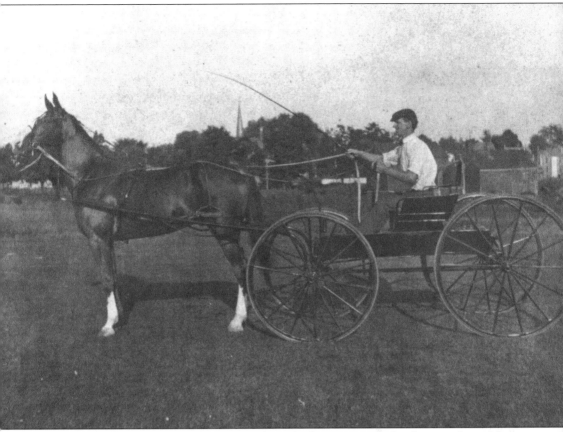

CLARENCE G. SKED WITH A BUGGY WHIP. This vehicle's enormous wheels can only qualify it as a buggy, driven by a sporty Clarence G. Sked. Posing with his buggy whip and horse, Sked is about to embark on a speedy trip. The horse may be one of those that Sked hitched up to a sled in the blizzard of 1914, a tremendous storm that shut down the borough of Pennington for four days. Dr. Edgar Hart left Pennington on Sunday afternoon to respond to an emergency call near Princeton. On Tuesday, a search party set out to look for him. The party included Mayor Walter Frisbie, George W. Scarborough, Dr. Frank Hart, and other borough notables, all transported in a sled drawn by Clarence Sked's team of horses. Though the intrepid team tailed the lost doctor to Princeton and back, he had no need of rescuing and arrived just after they did. Sked's horses were most useful in this attempted rescue mission, however, especially since the trains and trolleys were unable to run until the tracks had been shoveled clear by hand.

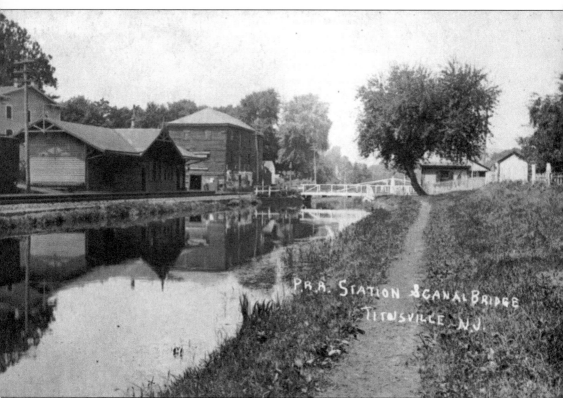

THE TITUSVILLE RAILROAD STATION. The railroad came to Titusville early and, by the mid-19th century, it had contributed significantly to the growth of this village. The Belvidere-Delaware Railroad was completed on the west side of the canal in 1851. It quickly became an important freight route, especially for coal, and also moved passengers north and south through the Delaware Valley. This railroad station, shown as it appeared in 1907, was built soon after the tracks were completed and was located on the south side of Church Road. The feed and grain storehouse, to the rear of the station across Church Street, was the second railroad building in Titusville. In 1871, the Bel-Del, as this railroad line was affectionately called, became part of the Pennsylvania Railroad System, and it remained in use until Conrail took over the tracks in 1976. This portion of the railroad is now part of the Delaware and Raritan Canal State Park.

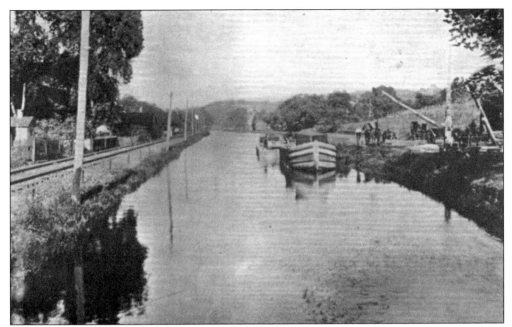

THE DELAWARE AND RARITAN FEEDER CANAL. This feeder canal was completed soon after the land was sold to the Delaware and Raritan Canal Company in 1832 by Uriel Titus and others. The feeder canal was the first great stimulus for growth in the village of Titusville. This c. 1907 photograph shows a mule barge being pulled along the canal; the railroad tracks can be seen to the west.

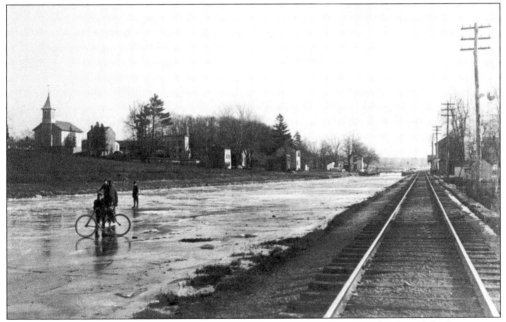

THE FROZEN CANAL. The canal froze over in winter, making passage back and forth across it a much easier matter. In warmer months, Titusville residents crossed by means of a bridge located near the railroad station. In this view taken looking southeast, the Titusville Methodist Church can be seen on the left. Note the bridge at Church Street in the distance on the right.

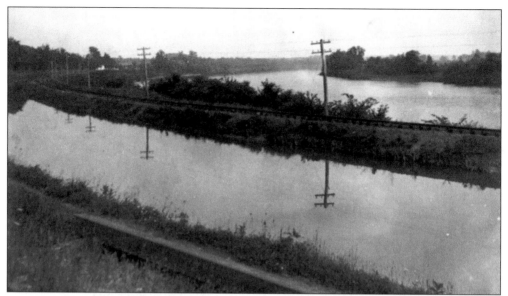

THE CANAL, THE RAILROAD, AND THE RIVER. Looking southwest, this photograph shows the feeder canal, the Pennsylvania Railroad tracks, and the Delaware River. The river was one of the first modes of transportation in the Hopewell Valley. Early settlers traveled back and forth to Pennsylvania on Durham boats, or they traveled north and south to Trenton, Philadelphia, and other major ports on log rafts.

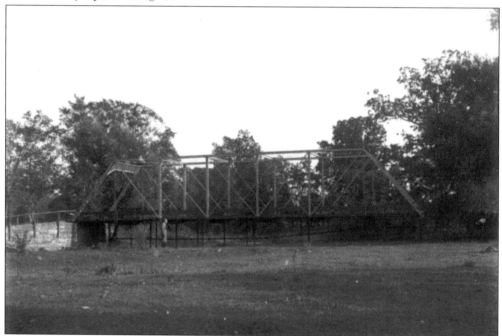

THE IRON BRIDGE OVER STONY BROOK. This iron truss bridge was built in Hopewell Township over the Stony Brook. It is a fine example of the type of bridge being built in the mid-1880s, with iron trusses supported by stone piers. Besides the bridge at Washington Crossing, two large bridges of this type survive in the township today: this one crosses the Stony Brook at Mine Road; the other crosses Jacobs Creek at Bear Tavern Road.

50

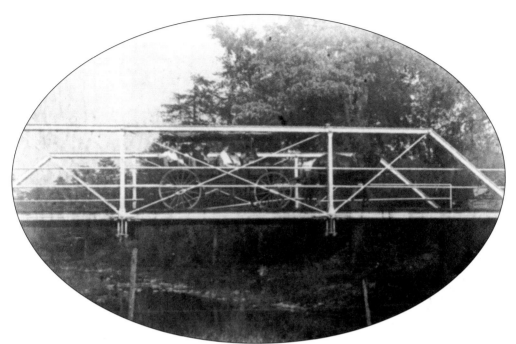

A Horse and Carriage Crossing Iron Bridge. Iron truss bridges were on the cutting edge of technology when first built in the late 19th century. Their narrow spans provided more than enough room for pedestrians, horses, and carriages. As the 20th century progressed, however, and automobiles became increasingly more prevalent, these bridges seemed smaller and smaller, relics of a bygone age.

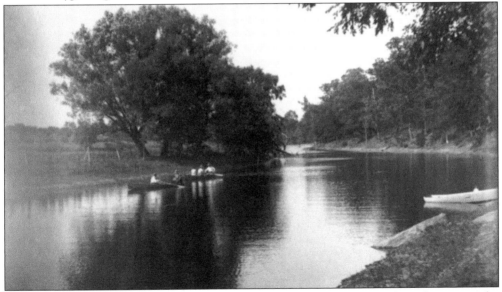

A Brook Scene, 1899. Boating on small waterways such as this one has always been a popular recreational sport. Hopewell's waterways include Beden Brook in the northeast, Stony Brook, which winds through the eastern half of the township, Jacobs Creek, to the west of Pennington, Fiddlers Creek, which flows westward toward Titusville and the Delaware, and Moores Creek, in the western corner of the township.

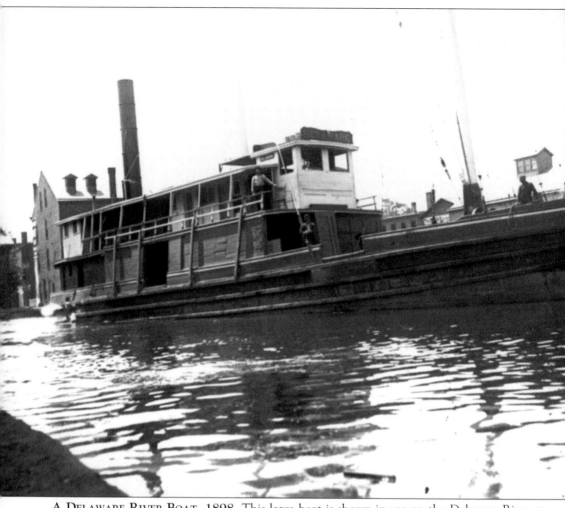

A DELAWARE RIVER BOAT, 1898. This large boat is shown in use on the Delaware River at the very end of the 19th century. This was a far cry from the deep-draft boats used by fur traders to navigate the Lower Delaware in the early Colonial days, or the canoes that were the only crafts able to manage the shallow waters of the Upper Delaware, above Trenton. The river soon became the main method for commercial transport in the Colonial period, and it remained paramount until the development of canals and railroads in the early to mid-19th century. Titusville and Washington Crossing were the Hopewell Township landing sites from whence agricultural products were sent downriver. Rafting timber downstream was also an important part of river traffic from the mid-1700s to the mid-1800s. Ferries were the only method of crossing the river before bridges began to appear in the 19th century. River traffic of all kinds declined quickly as other modes of transportation grew; thus, by the 20th century, the Delaware River was again a relatively quiet waterway, slowly regaining its scenic beauty.

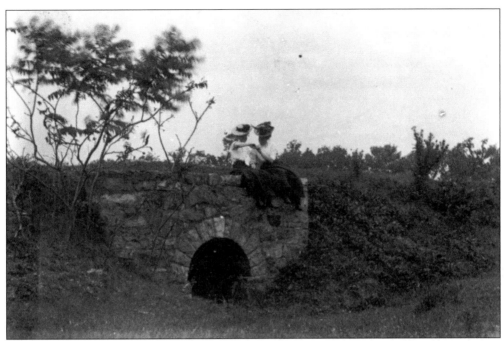

TWO YOUNG LADIES SITTING ON A STONE CULVERT. This *c*. 1900 photograph shows two young ladies enjoying each other's company while sitting on the edge of an arched stone culvert. Though the Mercer and Somerset Railroad line once ran across this culvert, they had nothing to fear, knowing that this railroad had been abandoned in 1879 and that the tracks had been removed a year later.

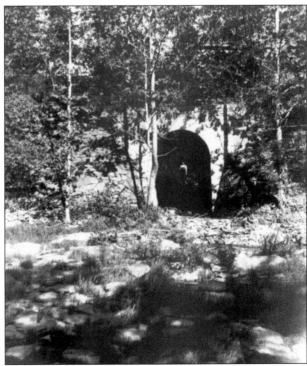

A STONE CULVERT LOST IN THE WOODS. Hidden in the woods of Hopewell Township are more stone culverts, such as this one. Mostly built when the Mercer and Somerset Railroad was laid out, these culverts have lain abandoned for more than a century and provide a look back in time to a rail network that failed. Forced out of business by the powerful Pennsylvania Railroad company, the Mercer and Somerset was not recalled with fondness; a historical pamphlet written in the early 1900s referred to it as a "jerkwater" line.

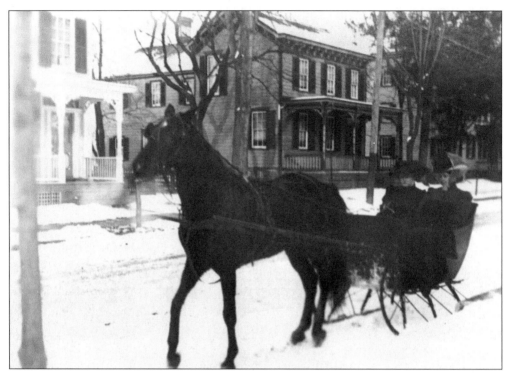

SLEIGHING ON DELAWARE AVENUE. This photograph, taken *c.* 1900, shows two Pennington women making use of another mode of transportation to proceed through downtown Pennington Borough. A one-horse open sleigh, such as this one, must have been quite handy after a storm, as the streets either had to be shoveled clear by hand or the difficult journey had to be made on foot.

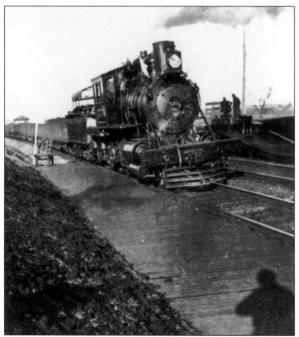

A TRAIN APPROACHING THE RAILROAD DEPOT. Steam engine No. 675 chugs to a halt at the Pennington railroad station, in this *c.* 1900 photograph. The Mercer and Somerset was the first railroad line to run through Pennington; its tracks were completed in 1873. The Delaware and Bound Brook line ran it out of business in 1876, and the station still standing today in Pennington was built in that same year.

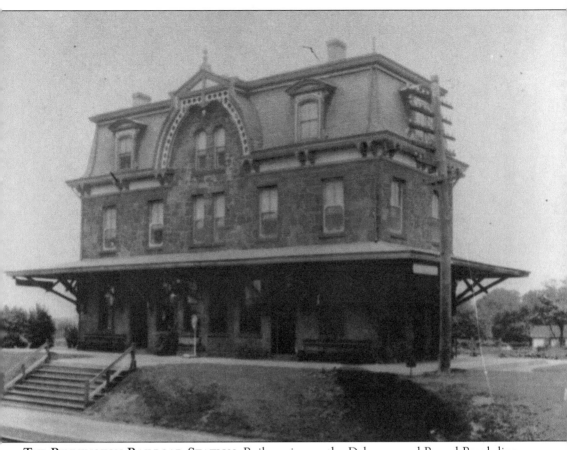

THE PENNINGTON RAILROAD STATION. Rail service on the Delaware and Bound Brook line began in Pennington on May 20, 1876. The first trains were greeted with excitement in the village, and free passes were given out to journey to Philadelphia that first day to see the nation's centennial celebration. For many years, the railroad was the central means of transportation from Pennington to Philadelphia and New York. This photograph shows the station as it appeared *c.* 1904, when no less than 53 trains a day stopped in the borough, carrying mail, passengers, and freight. Manning the station were an agent and three clerks, available around the clock. One man, named Frank Butler Jamison, was Pennington's stationmaster for 43 years, from 1888 to 1931. The station was built of stone in the Second Empire style. It is similar to the station that was built the same year in the village of Hopewell, yet the Pennington station has been converted to residential use.

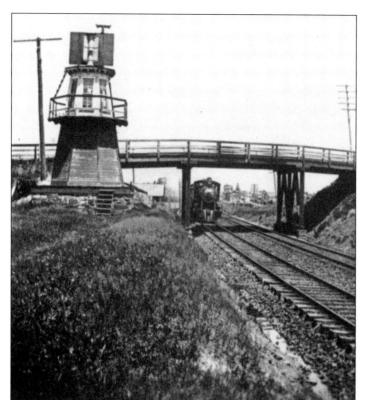

THE DELAWARE AND BOUND BROOK RAILROAD SIGNAL TOWER. Located just south of the station in Pennington was this signal tower. Looking a bit like a miniature lighthouse, it provided signals to approaching trains and was an important factor in maintaining safety. Andrew Wesner was one of the tower attendants, among his other jobs around the borough.

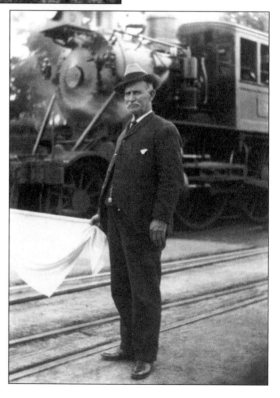

A FLAGMAN AT THE DELAWARE AND BOUND BROOK RAILROAD CROSSING. Pictured here with his signal flag is Joseph Thompson, who manned the crossing south of the Pennington Station. He worked for the railroad company for 37 years and was known to local children as "Bye, Joe," which his wife was heard calling to him each morning when he left for work.

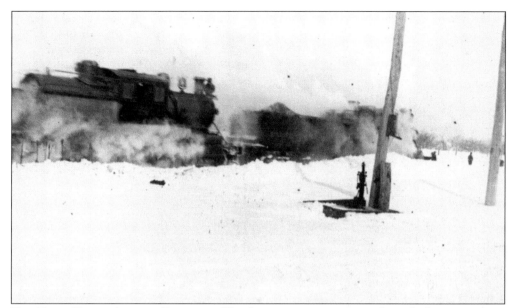

THE FIRST TRAIN AFTER A BLIZZARD. The first steam engine to get through the snow moves along in this photograph, taken *c.* 1900. Snow presented a difficult problem in the early years of railroad service, since large snowfalls and drifts could suspend service for days. Without today's road network and vast trucking delivery system, goods and people could be stranded in outlying areas, as the trains would not run.

TRAIN TRACKS OVER A STONE CULVERT. This panoramic view shows what a train traveler might have seen while passing through Hopewell Township in the late 19th century. The tracks pass over a stone culvert, and a farmhouse sits quietly in the distance. Farmland stretches from both sides of the tracks, dotted only by the occasional fence. In this way, Hopewell Township had more in common with the wide open spaces in the Western states than with New Jersey's increasingly urban areas.

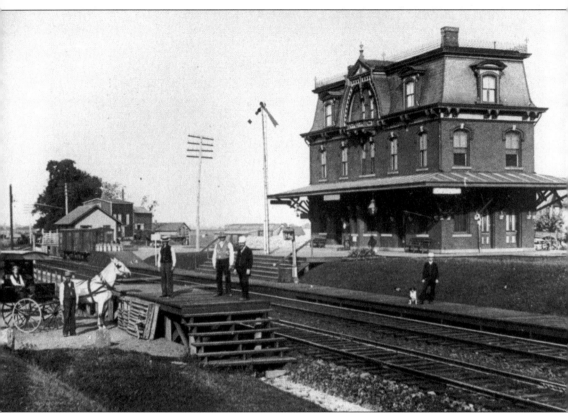

THE HOPEWELL RAILROAD STATION. This station was built in the village of Hopewell in 1876, the year the Delaware and Bound Brook Railroad came through, and it has stood intact for nearly 125 years. This railroad met with resistance from the Mercer and Somerset line, which had come to town six years earlier. Anticipating the problem, Delaware and Bound Brook tracks were laid down in two directions, going southwest from Bound Brook and northeast from the Delaware River. They were to join in Hopewell Township, near Van Dyke Road, but a segment of track called a frog was needed where the two train lines would cross. On January 5, 1876, the "frog war" broke out, as Mercer and Somerset employees physically tried to prevent the building of the frog. The state militia was called in two days later to restore peace to the area and by judicial order, the Delaware and Bound Brook Railroad was allowed to install the frog. Today, the amphibian remains as an unofficial mascot of the borough of Hopewell and Hopewell Elementary School.

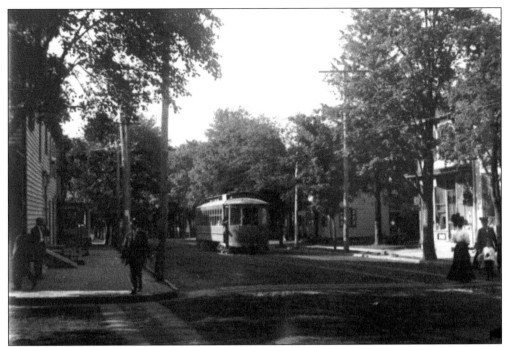

A TROLLEY CAR AT BLACKWELL'S CORNER. The next method of transportation to come to the area was the trolley, shown here heading toward the intersection of Main and Delaware Streets in the center of Pennington. The first trolley came to this borough in 1902, the result of efforts by the Pennington Improvement Association. The trolley was the precursor of the city bus, meant to provide cheap and convenient transportation to and from larger cities to smaller towns.

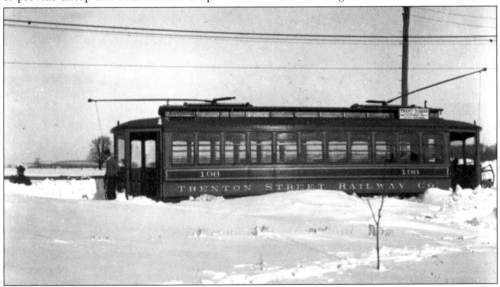

A SNOWBOUND TROLLEY CAR. Stuck in a 1910 snowfall is car No. 198 of the Trenton Street Railway Company trolley line. In better weather, residents enjoyed riding the trolley to Trenton and transferring from one car to another as a form of inexpensive entertainment. Even more fun was the ride down Democrat's Hill on North Main Street in Pennington, which was marked by a speedy descent and required sand on the tracks to aid in braking.

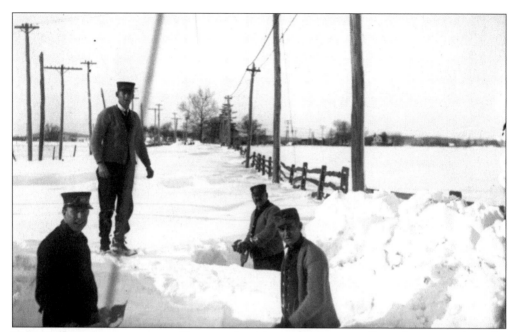

TROLLEY MEN SHOVELING THE TRACKS. As with steam engines, trolleys often got stuck in the snow and had to be shoveled out by hand by the trolley company employees. Shown here are four hardy men with a long stretch of track to clear. Trolley cars were heated by a round stove, but passengers often chose to disembark and walk the rest of the way. The trolley men were compelled to remain with their car.

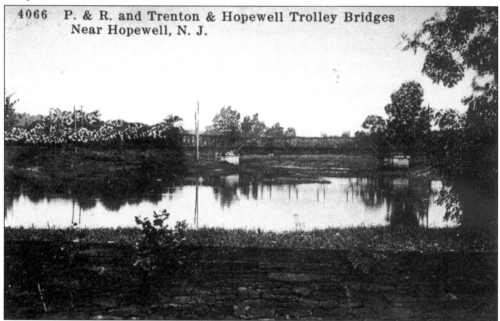

TROLLEY BRIDGES NEAR HOPEWELL BOROUGH. Pennington was not the only part of the Hopewell Valley to welcome the arrive of trolley service. The trolley was not as significant in Hopewell Borough as it was in Pennington, however, and service to and from Hopewell Borough ended in 1924. Service between Pennington and Trenton stopped in 1931.

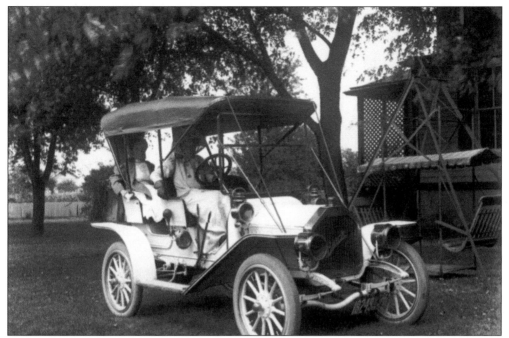

MARIE HART IN DR. HART'S AUTOMOBILE, 1909. Marie Hart is shown with two other women in Dr. Frank Hart's 1910 Buick, which featured gaslights and a bulb horn. Cars caught on quickly in the Hopewell Valley, and it was not long before they superseded trolleys, trains, horses, and carriages as the preferred means of transport.

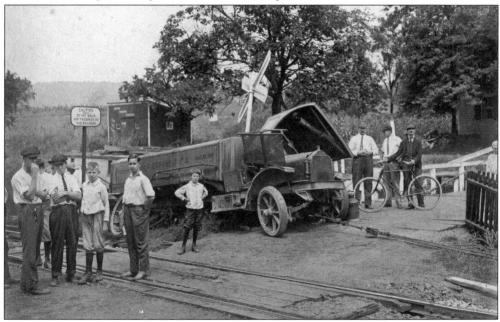

A TRUCK ACCIDENT NEAR THE RAILROAD TRACKS. Despite the posted warning to avoid walking or trespassing on the railroad, this truck appears to have fallen victim to a train passing through Titusville at Church Road. Railroad crossings have always been sources of danger, and this was as true in the Hopewell Valley as anywhere else.

Dr. Edgar Hart in his Automobile. Yet another Dr. Hart peers out of another early automobile in this photograph. Parked on a street in front of a Pennington home, Hart could certainly respond to emergency medical calls more quickly with his car than he could on foot— perhaps even in a blizzard.

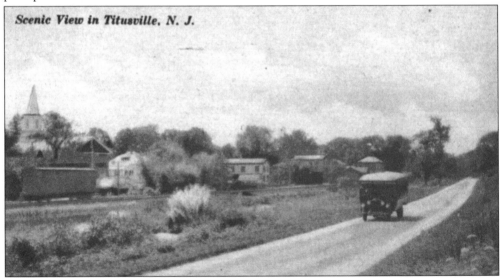

Scenic View in Titusville, N. J.

A Scenic View in Titusville with a Bus. River boats, canal boats, trains, sleds, horses, trolleys, automobiles, and finally, a bus. It was only a matter of time before cars led to larger compartments to transport more people along newly developed roads in the early 1900s. This c. 1930 postcard view shows the Trenton–Lambertville bus passing through the growing village of Titusville.

Five

PEOPLE
SOME FAMOUS, SOME NOT

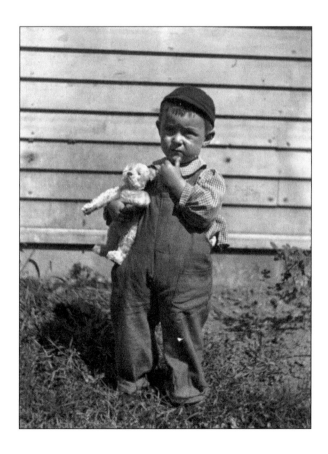

BOY WITH TEDDY BEAR.
No selection of faces from the Hopewell Valley would be complete without including the children. This unidentified boy, photographed by George Frisbie *c*. 1900, clutches a teddy bear, a toy that became very popular due to the presidency of Teddy Roosevelt. Perhaps this boy recalled his childhood plaything years later when, in 1912, presidential candidate Theodore Roosevelt made a campaign stop in Pennington.

REV. JOHN KNOX SHAW. This portrait shows John Knox Shaw, who was the fourth pastor of the Methodist Episcopal church in Pennington, now known as the First Methodist Church. He served from 1836 to 1837. In his second year, he went from house to house in the village soliciting contributions for a Methodist seminary, and his efforts led to the founding of the Methodist Male Seminary in Pennington in 1838.

REV. JOSEPH KEUPER. Roman Catholic members of Pennington Borough found their yokes lightened when they no longer had to travel to Hopewell Borough to attend Mass. The task of ministering to the spiritual needs of Pennington Catholics was given to Fr. Joseph Keuper, who said the first Mass in that part of the valley in the Dublin home of Patrick and Ellen Tyman. Today's Dublin Road marks the area where the first Irish Catholics settled near Pennington in the late 1800s.

REV. THOMAS O'HANLON. President of the Pennington Seminary from 1867 to 1872 and from 1876 to 1902, Dr. Thomas O'Hanlon did much to promote education in the village of Pennington. He not only used his own money to help the school when it was financially troubled but also helped the Roman Catholics become established in Pennington by donating money to help build the church.

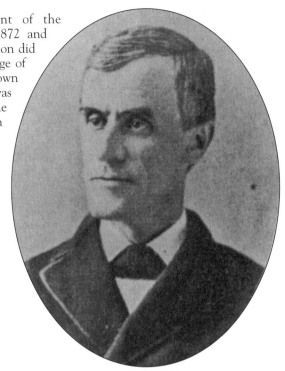

JOHN CONWAY. By 1916, St. James Roman Catholic Church had come a long way. Pictured here as he appeared in that year is lay trustee John Conway, looking every bit the dapper and successful gentleman. The Irish railroad men and their families who brought the Catholic faith to the southern part of the Hopewell Valley only decades before would surely have smiled at the success of their early mission.

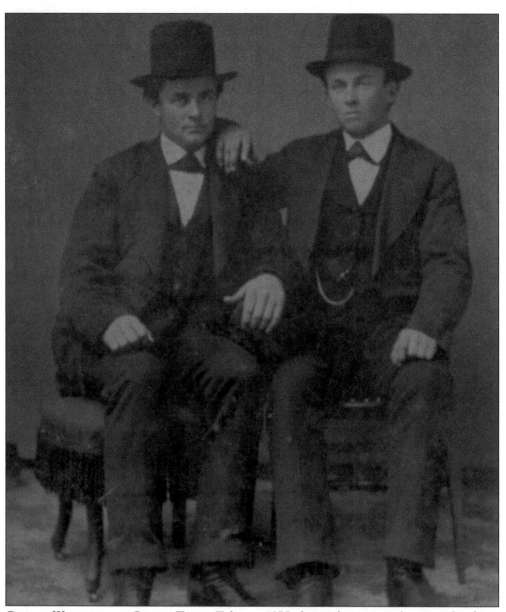

GEORGE WOOLSEY AND OLIVER TITUS. Taken *c.* 1875, this studio portrait shows two brothers-in-law in clothing reminiscent of Abraham Lincoln. George Woolsey had two brothers, William and Charles Woolsey, and the family lived in a brick house built in 1765 by their ancestor Jeremiah Woolsey. The house still stands on the Pennington-Washington Crossing Road. As children, the Woolsey brothers attended the old Bear School on the road to Washington Crossing. Jeremiah Woolsey's father, George Woolsey, was an original settler in Hopewell Valley, having emigrated from Long Island, New York, *c.* 1700. He bought 218 acres of land, and it remained in the family until 1929. Another member of the family, Henry Harrison Woolsey, fought in the Civil War battle at Gettysburg and died at Petersburg, Virginia, on June 18, 1864. Oliver Titus was a fifth-generation descendant of the Tituses who settled in Hopewell Township *c.* 1710. His diaries of the 1870s describe a life of farming; he and his friend George Woolsey married Phillips sisters from Harbourton.

UNCLE NOAH AND AUNTY TINDALL, 1880.
The Tindalls lived at 7 South Main Street in
Pennington and ran a sweetshop and ice-cream
parlor at that location for years. They were
members of the Methodist church, and villagers
knew better than to go to the Tindall store on
Wednesday nights, for that was when they
closed down to attend prayer meetings. The
Tindalls donated the Methodist church's first
bell in 1876.

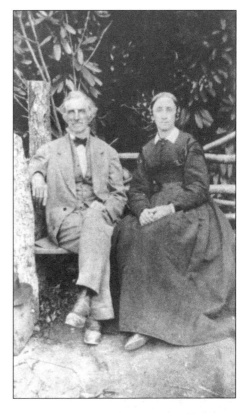

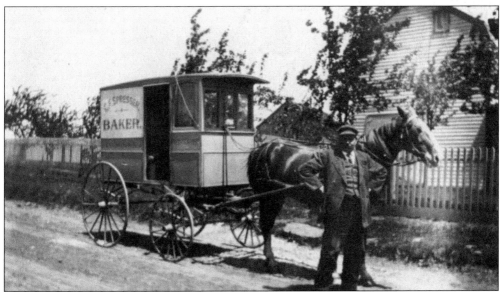

C.F. SPRESSER, BAKER. In the years c. 1900, it was common in the Hopewell Valley to see
horse-drawn wagons with vendors selling various fresh foods. One such gentleman was C.F.
Spresser, whose bakery was on Burd Street next to the Pennington Public School. Spresser
delivered his goods to homes throughout the southeastern part of Hopewell Township twice a
week. Before going out on his own, he had been a baker at the Pennington Seminary.

67

A BABY ON THE PORCH AT KUNKEL'S FARM. Col. John A. Kunkel purchased a farm in Pennington in 1894 and spent many years thereafter promoting the development of the newly created borough. He was known for his generosity at Christmastime, when children could come to his home on East Delaware Avenue to receive a box of candy and an orange.

A LITTLE GIRL, C. 1900. This charming little girl is unidentified, but she was photographed by George Frisbie in the Pennington area c. 1900. The large collection of photographs taken by Frisbie around that time are now part of the collection of the Hopewell Valley Historical Society; many of the more than 600 glass plate negatives provided images that are used throughout this book. Children have always been a favorite subject of photographers, and Frisbie was no exception.

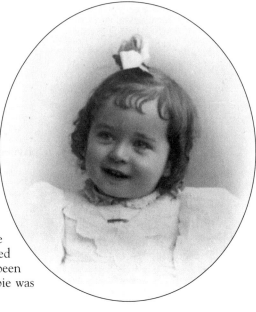

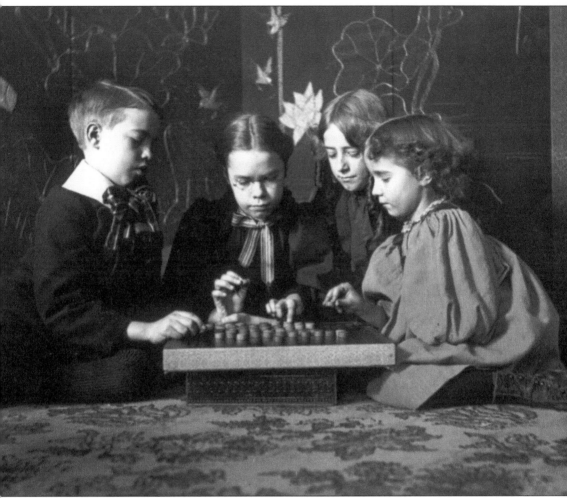

FOUR CHILDREN PLAYING CHECKERS. These boys and girls enjoy a game of checkers, in this *c.* 1900 photograph. Children's games at that time were much different from those played today. Along with checkers, chess was a popular indoor game, as were jacks, cards, and charades. It was a rare child who owned a game purchased from a store, for such playthings were seen as expensive frivolities. Instead, children created their own games, using objects found in and around the house. Many nostalgic scenes in films have revolved around old city games, such as stickball; in the country, which the Hopewell Valley certainly was at that time, games by necessity were created from things found in nature or on the farm. These children appear rather well-to-do and may have been privileged to be able to play with a handcrafted checkerboard, or perhaps this picture was taken especially to portray them in a light of plenty.

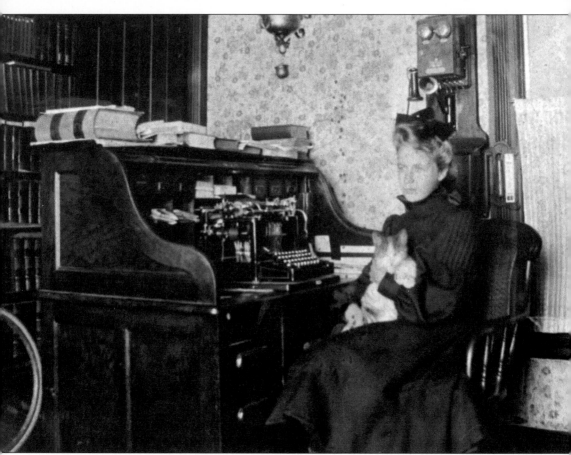

JESSIE DURLING. Jessie Durling, also seen as a student in the classroom photograph from the Academy Avenue School in chapter 7, graduated from that school in 1905 and later married Fred Maple. Her father was Pennington attorney Theodore D. Durling, who became the borough's fourth mayor when he was elected in 1899. He served six years in that office and was one of the borough's leaders, instrumental in bringing modernization and growth. His office was located at 8 West Franklin Avenue, which is where his daughter was photographed. Note the typewriter, law books, and telephone. Durling was one of the first telephone subscribers in the borough, and the telephone shown in this photograph is surely one of the early ones installed in Pennington. He also worked to bring electricity and trolley service to the borough.

TWO WOMEN STRIKE A PLAYFUL POSE. These two young women are clearly game to try out a new pose for photographer George Frisbie. While early photographs often portray stern and dignified subjects looking away from the camera, that is not the case here. Note that the finely dressed women gaze unblinkingly at their own reflections while the camera and photographer's head peek out at the bottom of the picture.

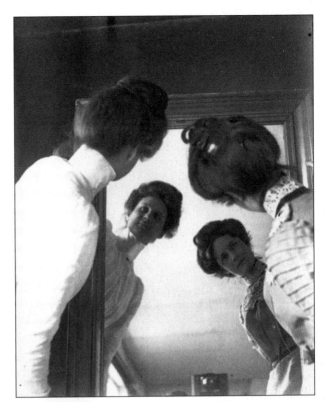

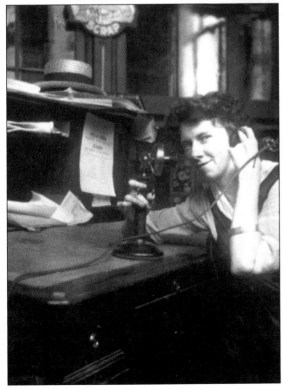

A WOMAN WITH A TELEPHONE. This young woman showcases the ever-growing importance of the telephone in the workplace. She is pictured with a "candlestick" telephone that was popular during the 1920s. Early calls were connected by an operator, until a frustrated undertaker in Kansas City invented the dial and automatic exchange in 1891. The undertaker was tired of the operator directing all calls for an undertaker to her husband's funeral business.

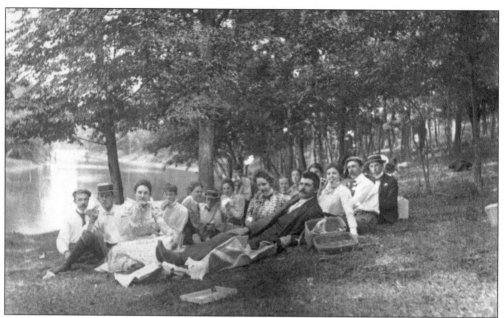

INDEPENDENCE DAY, 1899. Hopewell Valley residents enjoy a picnic at a location given only as Reeder's, which is thought to be on the Stony Brook near present-day Carter Road. Attire was casual for this celebration of the nation's birthday, and that night the group probably moved on to Pennington, where they enjoyed a spectacular fireworks display at Col. John Kunkel's farm.

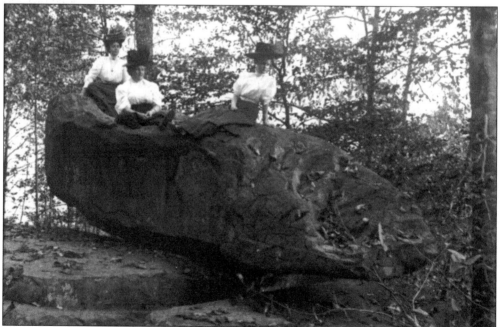

A DAY AT CRADLE ROCK. These young women sit atop Cradle Rock, enjoying a day's outing in their frilly blouses and elaborate hats. Cradle Rock was a popular spot for young people because it rocked back and forth like a cradle when boys or girls jumped up and down at either end. It is found in the woods along Province Line Road, southeast of Mount Rose.

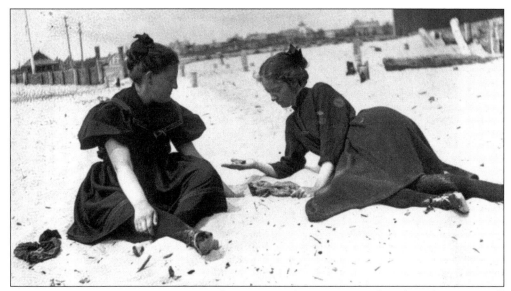

TWO WOMEN AT THE BEACH. Some things never change. Just as they do today, Hopewell Valley residents of a century ago enjoyed a day (or a week) at the beach. Though beach attire has been altered slightly from that seen in this photograph, the emphasis on fun and relaxation remains. Hopewell Valley residents favored the Jersey Shore town of Ocean Grove, which may be the location of this photograph.

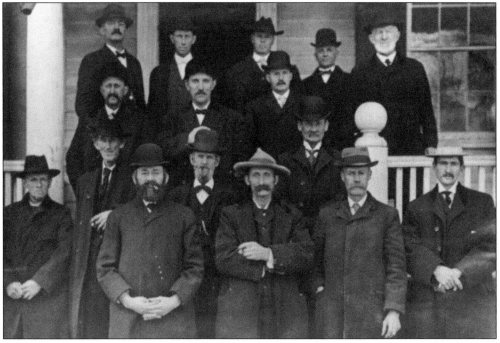

THE PLANNING OF ELM RIDGE ROAD. On March 15, 1909, these men met to plan the construction of Elm Ridge Road. They are, from left to right: (first row) Elwood Titus, John Ege, ? Scudder, David Voorhees, and Alfred Hunt; (second row) unidentified, Johnson Blackwell, and Calvin Updike; (third row) ? Scudder, unidentified, and unidentified; (fourth row) Thomas Cashel, Edwin Sharp, Leo Drake, Theodore Durling, and Archibald Updike.

HAROLD BLACKWELL, C. 1920. Born on the family farm in 1915, Harold is about five years old in this picture. A few years later, like many boys of his day, he shed his fancy clothes and became immersed in farm chores, milking cows twice a day, harvesting hay, shoveling manure, and feeding the pigs and chickens.

OLIVE AND HELEN BLACKWELL, C. 1910. These sisters were born in 1900 and 1904 and lived on a farm near Mine Road in Hopewell Township. Their grandfather was Oliver Titus and they had another sister, Anna Blackwell, who was born in 1910. Though dressed in their Sunday best for this portrait, their early life was spent on the farm, milking and feeding the livestock.

ANDREW WESNER. This bespectacled fellow was a familiar figure in Hopewell Township in the early 1900s. In 1897, he advertised secondhand bicycles for sale, with riding lessons given free with every purchase; lessons cost 50¢ if no bike was bought. In 1901, Wesner became Pennington's night watchman and special officer; he was succeeded in this post by Howard Hoagland. Wesner died in 1933.

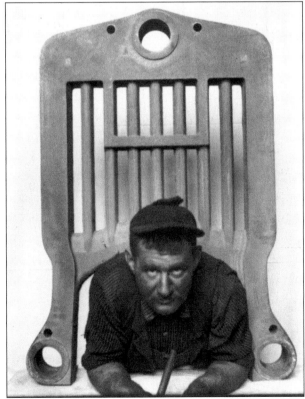

S.W. TITUS. Playful moments such as this were surely few and far between for the employees of the Pennington Foundry. The piece under which S.W. Titus has crawled appears to be part of one of the foundry's water heaters, which were advertised as being "unexcelled in warming homes, churches, and other buildings."

ARCHIBALD C. SERUBY AND FAMILY. Posing on the front porch of Col. John Kunkel's home in Pennington are Archibald C. Seruby and his children, dressed up for Christmas Day, *c.* 1900. A veteran of the Spanish-American War, Seruby was well-known in the area as the Peanut King. In *Pennington Profile*, Margaret O'Connell tells of how Seruby would arrive at sporting events dressed in his Prince Albert coat or double-breasted Chesterfield with satin lapels, shiny black shoes, and high silk hat. The author notes that he carried with him a large basket of peanuts and was said to have charmed all of those in attendance at baseball games, football games, and other matches for miles around. She relates his sales chant as "They're strong as a rail and never stale—and they're always for sale." She tells of his clever method of making it look like the buyer was getting many more peanuts than he really received; this trick fooled children, and adults simply enjoyed his cheerful patter. Seruby died in 1935 at age 58 and is buried in the African Methodist Episcopal Cemetery in Pennington.

GEORGE AND EDGAR FRISBIE, 1898. This portrait shows photographer George Frisbie and his son Edgar Frisbee in a studio setting, where the stark background serves to highlight their faces. The father was then 46 years old; his son, only five. Together they look out at today's observer as relics of a century past, inhabitants of the Gay Nineties, whose futures lay ahead of them in the dawning 20th century.

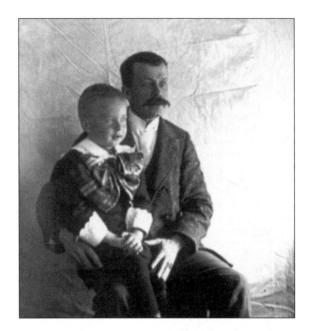

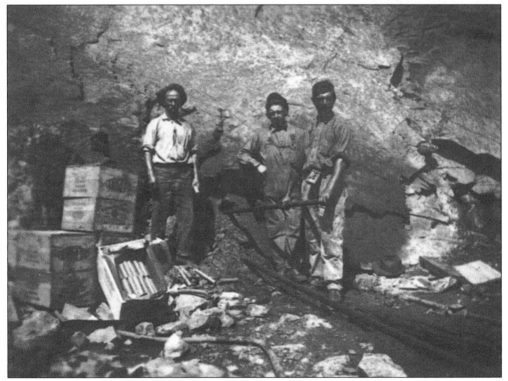

MEN AT TRAP ROCK QUARRY. Pictured with cases of dynamite are three hardworking men, who appear to be boring a hole prior to blasting. Quarrying in Hopewell Township began on Baldpate Mountain in the 19th century but greatly expanded in the 20th century, as the call for its products grew. Traprock Industries continues its operations today in and around the Hopewell Valley.

PATRICK TYMAN. Patrick Tyman can truthfully be called one of the founding fathers of St. James Roman Catholic Church in Pennington. His was among the first Irish Catholic families to settle in Dublin (now Dublin Road) in the 1870s, and the first Roman Catholic Masses in southern Hopewell Township were held at his home in 1895. In 1898–99, Tyman was one of several men to construct St. James Church by hand.

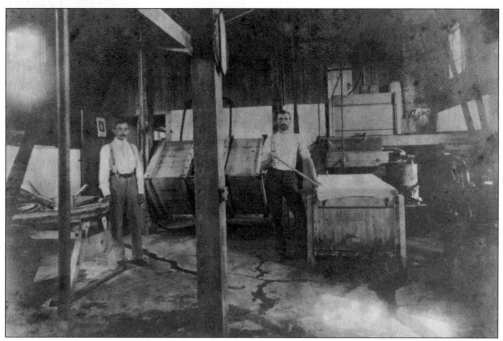

THE HARBOURTON CREAMERY. Pictured here c. 1920 are creamery workers Joseph Johnson and Sam Burns. This creamery was founded in 1898 by local dairy farmers, and the building that housed it still stands on the north side of Harbourton-Rocktown Road. Another creamery was in operation around the same time in Hopewell Borough. These businesses were the result of increasing dairy farming in the Hopewell Valley in the late 19th century.

CHARLES HENDRICKSON, LAMPLIGHTER. Known in Pennington as "Heavy Dick," Hendrickson was born *c.* 1825 near Allentown. He lived there till age 21 and then spent time in Princeton and the village of Hopewell before settling in Pennington in 1870. The June 1870 census of Hopewell Township lists him as a waiter in the Swan Hotel, and he subsequently found employment as a driver, taking passengers to and from train stations for several years. He also delivered mail and carried express packages all over the township. In the late 1890s, street lamps were installed in downtown Pennington, and Hendrickson was hired as the borough's first lamplighter. He is shown in this photograph on South Main Street, in the process of cleaning out one of the lamps' glass globes. He is said to have taken great pride in his lamps, and stories are also told of the many clever gadgets he invented as laborsaving devices in his home. His career as lamplighter was brief but memorable, ending with his death in 1902.

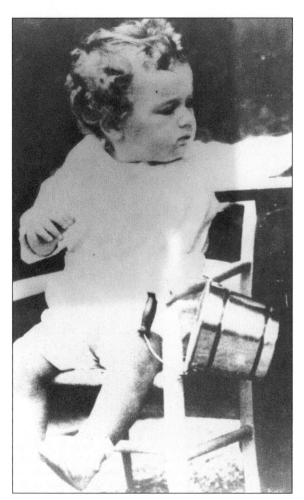

CHARLES A. LINDBERGH JR., 1931.
When Charles Lindbergh, world-famous aviator and beloved celebrity, wanted a beautiful location for the country home he was to share with his wife, Anne Morrow Lindbergh, and their son, he took to the skies, locating by aerial view the perfect property nestled above Hopewell Township in the Sourland Mountains. This picture shows his son Charles Lindbergh Jr. celebrating his first birthday, eight months before tragedy fell upon the family. Fortunately, the property has evolved from a site of tragedy to a place of hope. In June 1933, the Lindberghs turned the property over to a board of trustees, giving the estate the name "Highfields" in memory of their son's favorite greeting to his father: "Hi, Hi." In 1941, Highfields Association conveyed the property to the state for indigent children with heart ailments. In the 1950s, it became a juvenile rehabilitation center and in 1990, it was rededicated to the memory of former site superintendent Albert D. Elias and given the name it retains today, the Albert D. Elias Rehab Group at Highfields.

THE LINDBERGH WANTED POSTER. Within days of the abduction of Charles Lindbergh Jr., this wanted poster was distributed to 1,400 law enforcement agencies. Hopewell Valley police were immediate in their response to the family's call for help, and within hours the New Jersey State Police had set up temporary quarters at the estate. It was with great sadness that truck driver William Allen discovered the baby's body in the woods just off Hopewell-Princeton Road near Mount Rose on May 12, 1932.

WANTED

INFORMATION AS TO THE WHEREABOUTS OF

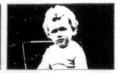

CHAS. A. LINDBERGH, JR.
OF HOPEWELL, N. J.

SON OF COL. CHAS. A. LINDBERGH
World-Famous Aviator

This child was kidnaped from his home in Hopewell, N. J., between 8 and 10 p. m. on Tuesday, March 1, 1932.

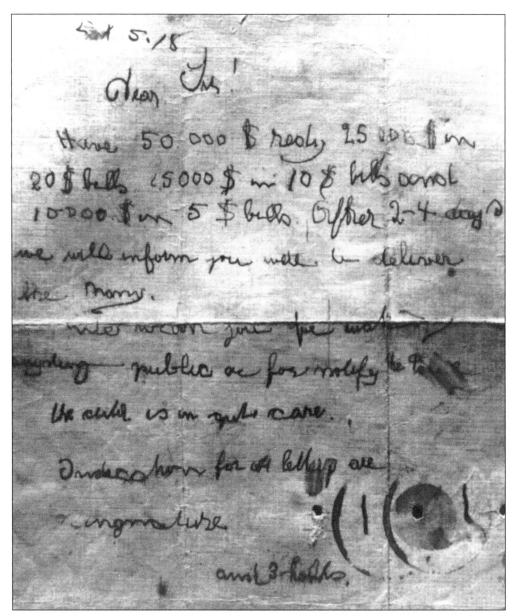

THE NURSERY RANSOM NOTE. The note pictured above was found in Charles Lindbergh Jr.'s nursery on the night of the kidnapping. The first in a series of 15 ransom notes linked to Bruno Hauptmann, this was one of the most important pieces of evidence used in the trial. This note was examined by Hopewell Township native Russell Snook, who headed the New Jersey State Police Bureau of Identification.

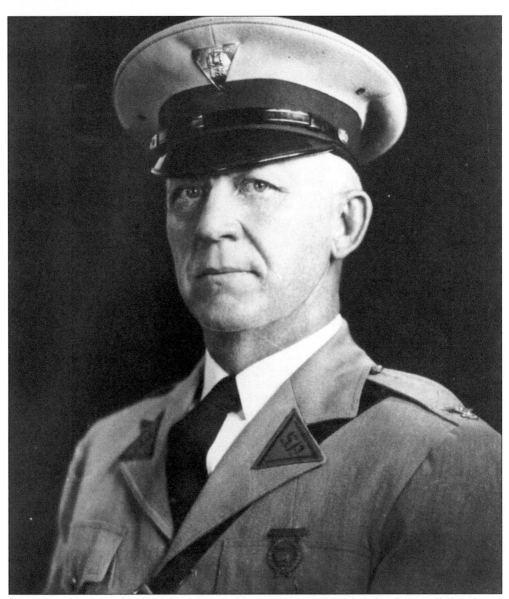

COL. RUSSELL ASHER SNOOK. A 1919 graduate of Hopewell High School, Russell Snook was born in the hamlet of Woodsville, a descendant of the early Snook family settlers. He married Susie Titus of Marshalls Corner and, after serving in the navy, he entered the newly created New Jersey State Police Academy in 1922. He worked closely with Col. H. Norman Schwartzkopf, who headed the state police, and when the state Bureau of Identification was established in 1930, Snook became its first supervisor. Only two years later, the Bureau of Identification faced its biggest job—preparing all exhibits and photographs for the Bruno Hauptmann trial involving the kidnapping and death of Charles Lindbergh's son. Snook's fingerprinting analysis skills proved invaluable. After serving in the National Guard during World War II, Snook returned to the state police and served as superintendent from 1952 to 1954. Believing that too many troopers were dying needlessly in motorcycle deaths, Snook disposed of all cycles and let it be known that "man is the most valuable asset in police service." Following his retirement, he was a consultant for the U.S. government.

Six

COMMERCIAL
ESTABLISHMENTS

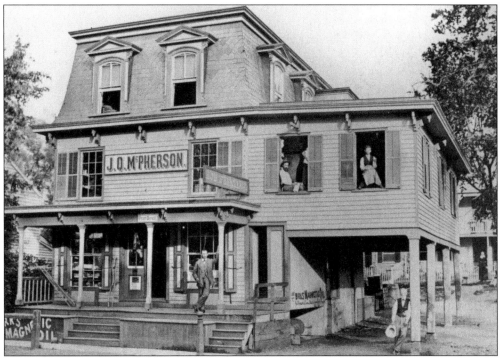

THE HOLCOMBE BROTHERS GENERAL STORE. Shown here as it appeared in the 1880s, this building housed a store, a post office, and the offices of the *Hopewell Herald*, the village newspaper. Note the "Job Printing" sign on the second story. The building was constructed in the 1870s with only two stories; the third was added sometime before this photograph was taken.

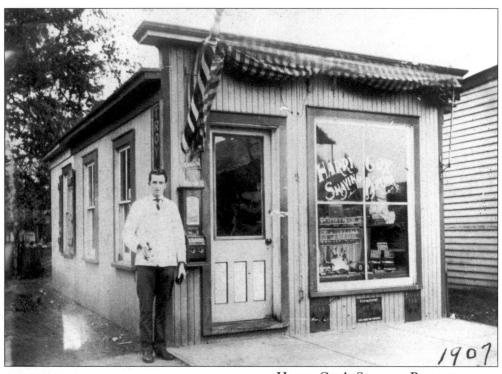

1907

HARRY COX'S SHAVING PARLOR. Pictured with his shaving cup and brush is Harry Cox, a Hopewell Borough barber, outside his "shaving parlor" in 1907. It was located near the corner of East Broad Street and Seminary Avenue. Cox, a regular advertiser in the local newspaper, called himself a "tonsorial barber" and drew special attention to his Fraley hand vibrator for special face and scalp massage.

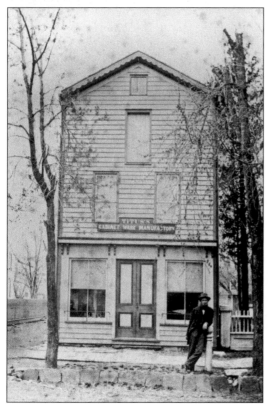

TITUS'S CABINET WARE MANUFACTORY AND STORE. Daniel C. Titus took over this undertaking and furniture business from John Titus in 1851. A furniture store occupied the first floor and on the second floor, Titus manufactured furniture and cabinets. This building was located on Main Street in Pennington, the second building in from the southwest corner of its intersection with Delaware Avenue.

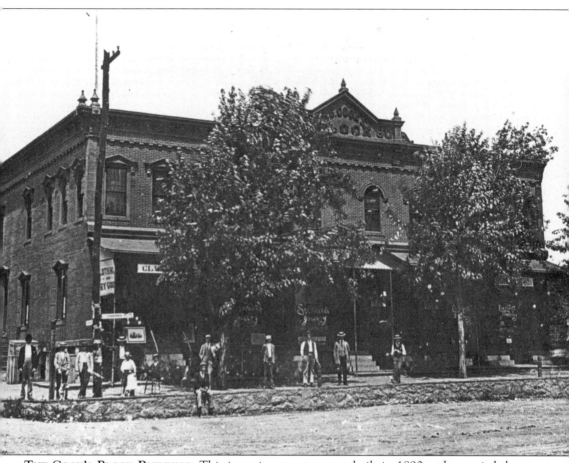

THE COOK'S BLOCK BUILDING. This imposing structure was built in 1890 and occupied the northeast corner of East Broad Street and North Greenwood Avenue. This busy hub of activity housed several stores, until it burned down on July 11, 1899—despite its favorable location next to the borough firehouse. The fire caused a loss estimated at $20,000. The block was occupied by T.J. Sheppard's grocery business and residence; M.D. Puglia, a barber; and the main office of Hopewell Telephone and Construction Company. Other businesses lost in the fire included A. Zanelli's fruit store, James Smith's tailor shop, and the post office, run by F. F. Holcombe. The post office was relocated to a store in the rear of Holcombe's block, a building diagonally across the street. Happily, there was only a little mail in the post office when it burned. Cook's Block was described in an article after the fire as "not a desirable building for either stores or a dwelling," but it was "well rented, owing to its central location" right in the middle of downtown Hopewell Borough.

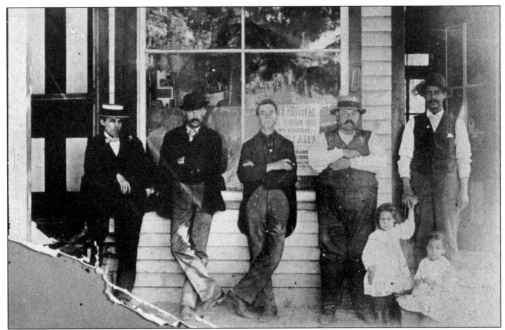

ARNOLD'S BARBERSHOP. Standing outside the Hopewell Borough barbershop of Paul Arnold, these men display the hats and mustaches fashionable prior to the dawn of the 20th century. Arnold was among those men of Hopewell Borough who could be found enjoying the horse racing at the Glenmoore Stud Farm, located at Glenmoore, west of Hopewell Borough and just east of Marshalls Corner.

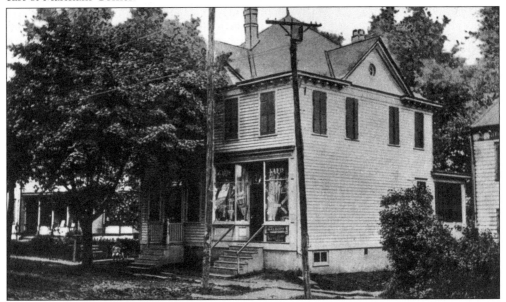

HART'S STORE. Little is known about this small store, other than its location on West Broad Street in Hopewell Borough. This photograph was taken c. 1910; since that time, the building has been home to several businesses, including Allen's Flower Shop and an ice-cream store run by the Fritz family. In 2000, the building was again being renovated, awaiting the arrival of another new business.

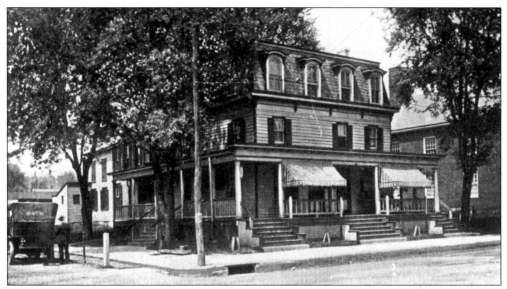

THE HOPEWELL HOUSE, C. 1910. Currently the Historic Hopewell House liquor store on West Broad Street in Hopewell Borough, this building was originally a two-story residence during the American Revolution. It was later bought by Ira Stout in 1815. After the Franklin and Georgetown Turnpike was built *c.* 1820, Stout and his son converted it into a tavern. It was enlarged *c.* 1870 and later became a hotel.

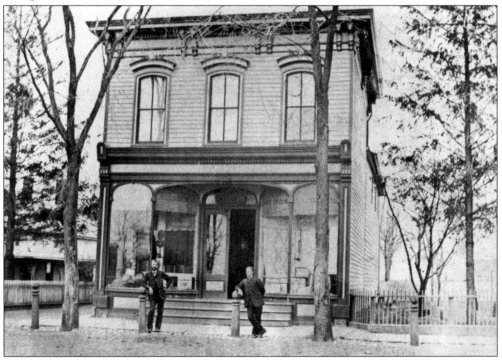

J.A. FRISBIE AND SONS GROCERIES AND DRY GOODS. Pictured *c.* 1885, this store was established on South Main Street in Pennington in 1843. One of the larger stores in town, it survived as a store under several names and is still in use today. Standing in front of the store, on the right, is George Frisbie.

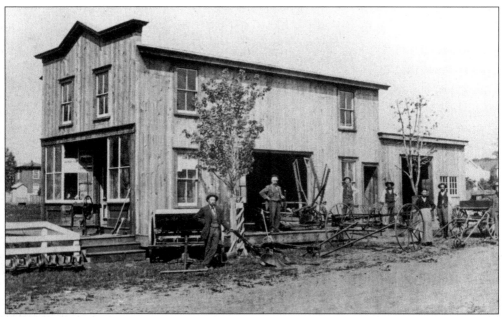

THE PIGGOTT AGRICULTURAL IMPLEMENT SHOP. Located near the corner of Mercer Street and West Broad Street in Hopewell Borough was this shop, which provided tools for the farming community of Hopewell Township. The shop was opened *c.* 1880, and this photograph depicts some of the wares for sale *c.* 1890.

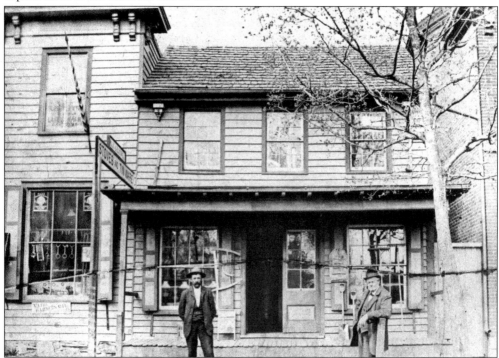

STOVES AND TINWARE. Another early store in downtown Pennington was the establishment pictured here, which was known as Welling and Wiley's. An 1860 map of the village lists this store as one dealing in hardware, stoves, and tinware.

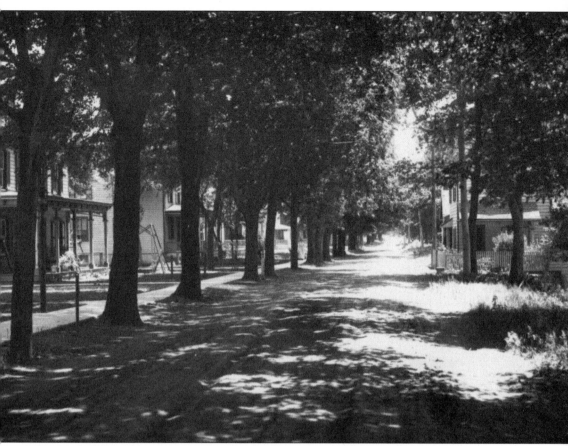

A STREET SCENE IN TITUSVILLE. This view looks south along River Drive in Titusville. By the time this photograph was taken in the early 1900s, the village's building boom had come and gone and the commercial area was to remain essentially unchanged for many years. Though Pennington and Hopewell Boroughs had incorporated years before, Titusville, which remains the largest village in Hopewell Township to this day, never officially split off on its own. Early in the 20th century, Titusville and Washington Crossing became fashionable summer vacation spots for residents of Trenton, located several miles to the south.

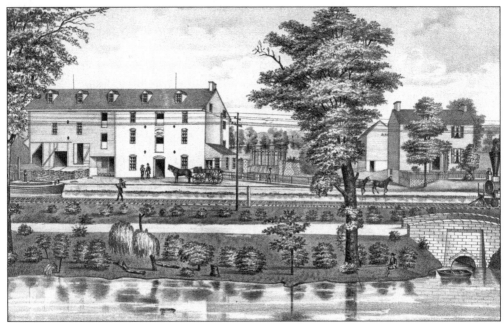

AGNEW AND SNOOK'S MILLS, ENGRAVING. This engraving from the *1875 Combination Atlas Map of Mercer County* pictures the flouring and sawmills situated along the feeder canal in Titusville. While logs were originally moved by rafting along the water, the arrival of railroads changed and expanded the manner in which these products were sent to market.

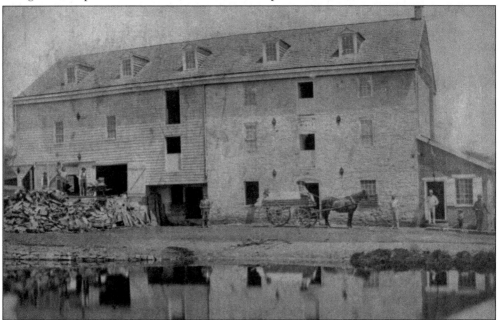

AGNEW AND SNOOK'S MILLS, PHOTOGRAPH. Compare this photograph of the same mill. The Belvidere-Delaware Railroad tracks cannot be seen in this closer photograph, but the importance of water and its proximity to the mill cannot be overstated; it was not only a means of transporting goods but also a source of power in preelectric days. Only surface remains can be seen today where this mill once stood, at Fiddler's Creek northeast of Route 29.

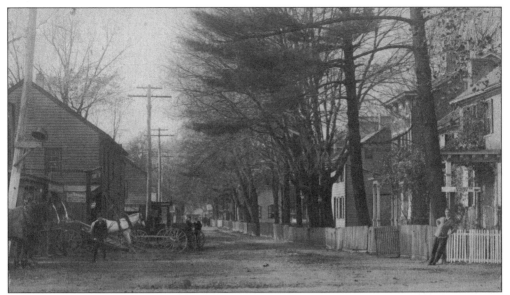

THE COLUMBIA WAGON LIVERY. This wheelwright and livery stable was photographed in Titusville in 1909. The view looks north from the Church Street intersection. Beyond the livery lies the post office and the Harbourt general store. This wheelwright shop was long ago converted into a residence and can still be seen on River Drive in Titusville.

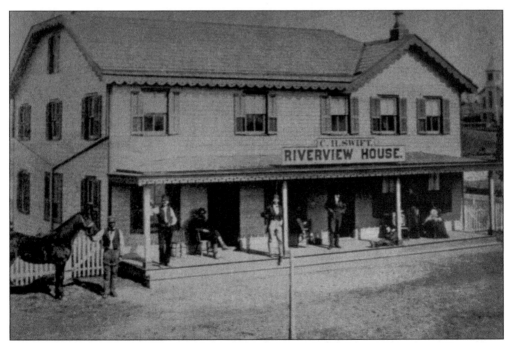

THE RIVERVIEW HOUSE. The logs being floated down the Delaware River to mills, such as Agnew and Snook's in Titusville, brought with them rafters, who often needed a place to stay for the night. In response to this demand, the Riverview House, which had been built in the 1830s, was expanded into a hotel in 1878 to serve the busy river traffic. Most rafters slept on the floor in the attic.

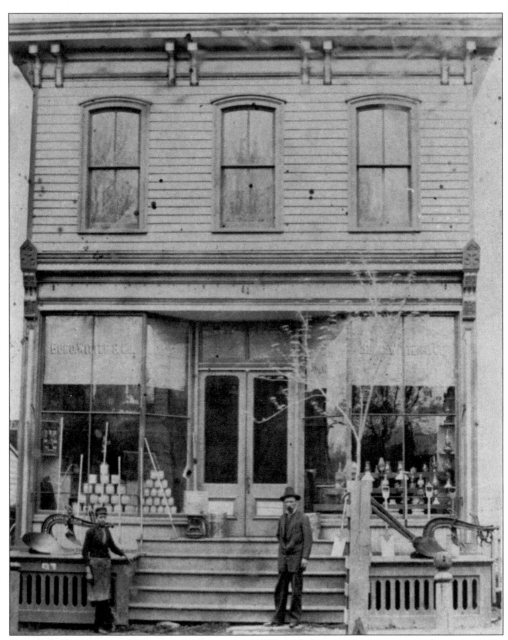

THE J.S. BURD AND COMPANY, HARDWARE. West Delaware Avenue was a busy street in Pennington when this photograph was taken in 1881. Though the signs in the window read "Burd, Witter & Co.," the store had become J.S. Burd & Company in 1878, when J.S. Burd and J.E. Burd purchased it from the former owners. On the left is Charles K. Yard and on the right, owner J.S. Burd. The Burd hardware store became a mainstay of downtown Pennington for many years to come and was often the place where local residents bought new machines. Originally established in 1850, the business has been in continuous operation as a hardware store for 150 years, always in the same location. Known today as Pennington Hardware, it retains the charm of an old-fashioned store while serving the residents of Pennington and beyond with old standbys and new gadgets.

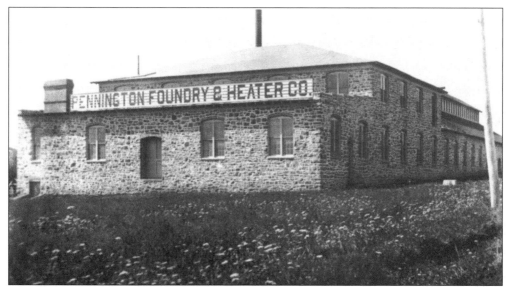

THE PENNINGTON FOUNDRY AND HEATER COMPANY. The only factory in Pennington, this building was situated on West Franklin Avenue and housed the Pennington Foundry and Heater Company from 1900 to 1912. By 1914, the company had been replaced by the Peerless Insulated Wire and Cable Company, which was capable of manufacturing more than a mile of cable or wire in a day. In the late 1930s, Scharf Brothers Candy occupied the building, until a scandal developed over sugar being dumped in the local brook, causing algae to grow wild; after that, the Scharf brothers fled to Cuba.

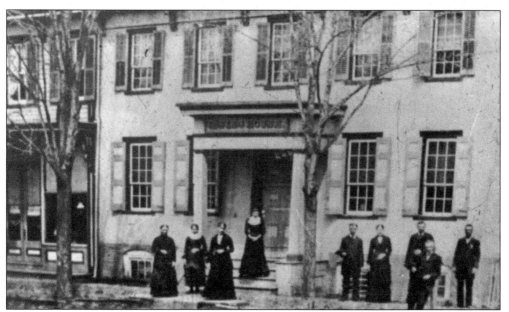

THE IRVING HOUSE. Described as one of the special prides of Pennington, the Irving House, shown in 1891, was a boardinghouse, restaurant, and sweetshop all in one. The building was erected before 1800; the Irving House first occupied it in 1880. In 1890, Pennington Borough was created as a separate political unit from Hopewell Township. The election, in which 124 votes were cast, was held at the Irving House.

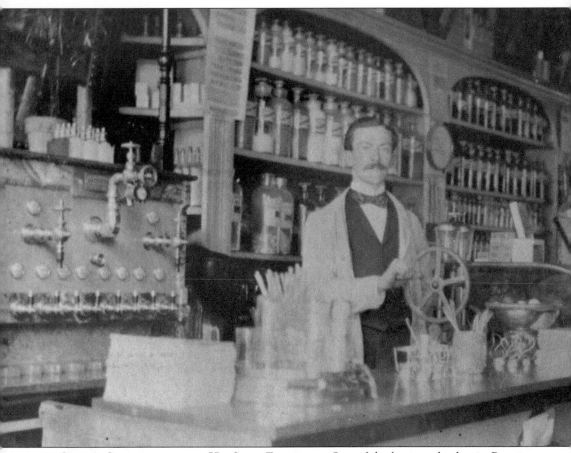

GEORGE SCARBOROUGH AT HIS SODA FOUNTAIN. One of the business leaders in Pennington in the latter part of the 19th century was George W. Scarborough. He established the first soda fountain in the village in 1887, and his drugstore provided various medicines to cure the ills of local residents. He helped raise funds for the start of the Pennington Fire Company in 1892, persuaded Bell Telephone to bring telephone service to the borough in 1897 (the first telephone was installed in Scarborough's Drugstore), supported the public library, and took photographs that have preserved images of Pennington from more than 100 years ago. The building in which Scarborough opened his drugstore in 1886 was demolished in 1960 to make room for a post office, which did not last 40 years in the same location.

THE MCCUE O'CONNELL AND FARR GENERAL STORE. In 1921, Pennington was home not only to W.S. Durling's grocery store but also to this store, located at 28 South Main Street. Changing times brought the gasoline pump seen in front of the store. Joseph McCue was an original owner but by 1940, when the store closed, it went by the name of O'Connell and Farr.

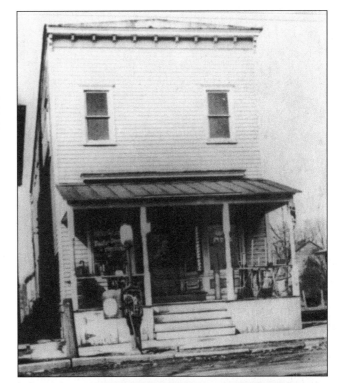

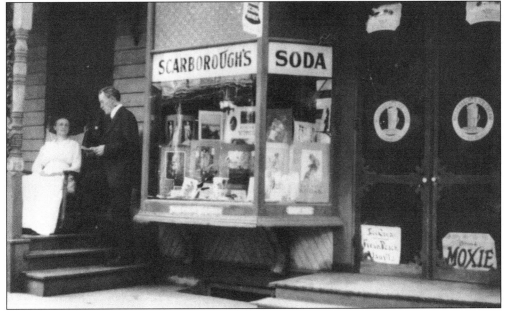

GEORGE AND CORA SCARBOROUGH AT HOME. Druggist George Scarborough and his wife, Cora Scarborough, are pictured here on the porch of their home at 9 West Delaware Avenue. Scarborough bought this house and the adjoining store in 1901, moving his store from its original location at the corner of South Main and West Delaware Streets. The building at that original location, which Scarborough purchased in 1886, had housed a drugstore operated by Titus and Lewis in the early 1800s.

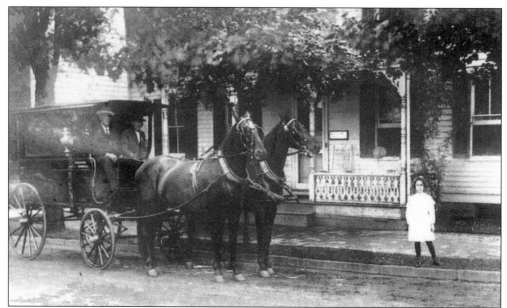

THE N.R. BLACKWELL FUNERAL SERVICE. Established in 1881, the Blackwell Funeral Service has operated continuously in Pennington for almost 120 years. This photograph, taken *c.* 1912, shows the home of Nathaniel R. Blackwell, who is seated on the right in the "removal wagon." The small girl standing to the right is his daughter Elizabeth Blackwell, who worked in the family business (renamed the Blackwell Memorial Home) until her death in 1972.

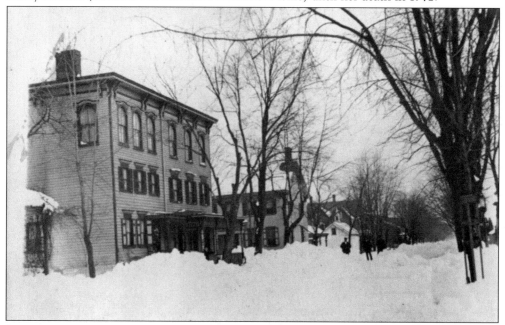

BLACKWELL'S CORNER. Another store in Pennington Borough was the Blackwell Store at the corner of Main Street and West Delaware Avenue. Known locally as Blackwell's Corner, it was a favorite spot for men to gather to discuss the news of the day. This photograph was taken in 1922. The building was constructed in 1858 and still remains, home to a drugstore and a pizzeria.

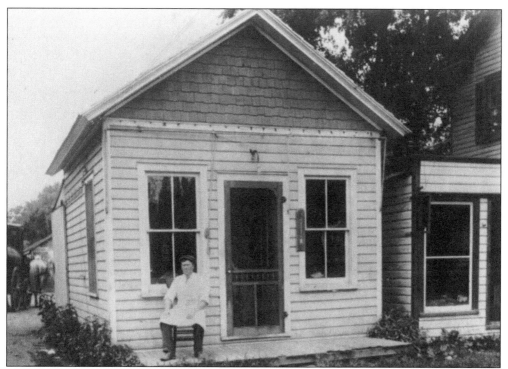

CHARLES LEMING IN FRONT OF HIS BUTCHER SHOP. Like many a tradesman of his day, Leming learned his trade working for another person before branching out to open his own business. This shop stood at 26 South Main Street in Pennington and is shown as it appeared in 1912. Leming dressed meat for almost 50 years; similarly long-lived was Sam Auletta, whose cobbler shop can be seen to the right.

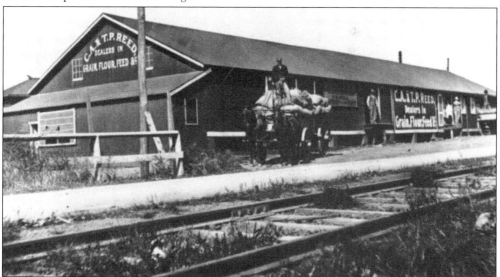

C.A. AND T.P. REED FEED STORE. This 1903 photograph shows the Reed feed store, located on North Main Street in Pennington by the trolley tracks. In the center of the photograph, a horse-drawn cart sets off to deliver sacks of goods. The Reeds also owned a gristmill outside of Pennington on the Stony Brook, and ice from the brook was stored there in the winter.

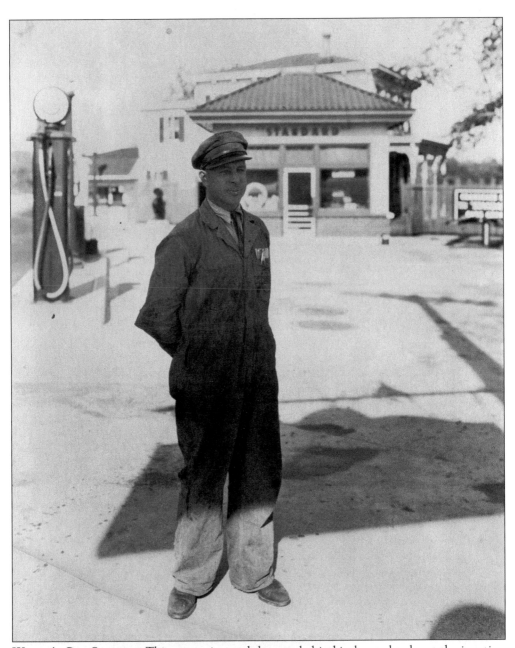

WEART'S GAS STATION. This gas station and the area behind it, located today at the junction of Route 31 and the Pennington-Hopewell Road, have long been the site of much activity in Hopewell Township. This photograph from the 1930s shows Mr. Weart in front of his station, as he appeared to numerous motorists of the time. He lived with his family in the house behind the station, though that house has long since been moved to the other side of the street. Downstairs in the house was a bar that was popular with local residents. Weart also owned the pond behind the station, known then as Weart's Pond. People came from miles around in the summer and paid a small fee to swim there; in the winter they came to ice skate. Weart had a small car to which he attached a plow to clear the snow from the pond for skaters. He also had a small bathhouse, which doubled as a warming house in cold weather.

Seven

EDUCATIONAL

INSTITUTIONS

THE HART'S CORNER SCHOOL CLASS OF 1912. At the intersection of Scotch Road and Washington Crossing-Pennington Road was the Hart's Corner School, which was recently moved. This photograph was taken on June 19, 1912. Pictured from left to right are the following: (front row) Edgar Reside, William Warner, Samuel Reside, Raymond Worth, Zelda Beaston, Belva Reside, Charlotte Richmond, and Bessie Suydam; (middle row) John Levanduski, James Mount, and Maude Oldis; (back row) John Oldis, Earl Burroughs, Charles Woolsey, Bessie D. Sked, Florence Warner, Alice Mount, and May Woolsey.

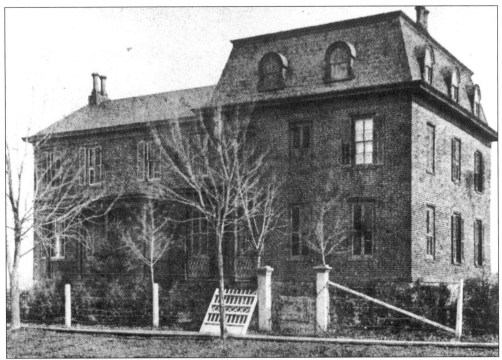

MISS BOGGS'S FEMALE SEMINARY. Shown here before 1900 is what was considered the "finest school in which a young lady might gain an education," according to Alice Blackwell Lewis, author of *Hopewell Valley Heritage*. Established in 1867, the school was run by Elizabeth Boggs at 23–27 East Broad Street in the village of Hopewell.

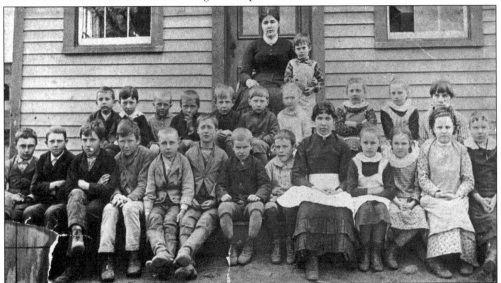

THE WOOSAMONSA SCHOOL CLASS C. 1890. Serving the students of Hopewell's school district 11$\frac{1}{2}$ was this one-room schoolhouse, located at the corner of Woosamonsa and Poor Farm Roads. The building was constructed in 1876 and may have replaced an earlier schoolhouse built of logs. Records show that the enrollment in 1879–80 was 63; however, not every student came each day, so average school attendance was around 30.

A HOPEWELL PUBLIC SCHOOL CLASS PHOTOGRAPH. The large size of this student body shows how quickly the population of Hopewell Borough was growing by the beginning of the 20th century. The first school in the vicinity of the Baptist meetinghouse was a parochial school built *c.* 1740; it was on Joseph Golden's farm and was made of logs. Next came the Hopewell Baptist Academy, which existed as a school on West Broad Street from 1756 to 1767. The third schoolhouse was built near the meetinghouse *c.* 1785, where the cemetery is today. The fourth schoolhouse in the village of Hopewell was built in the 1850s on West Broad Street and was known as the Hopewell Academy. It survives today as a residence. The Hopewell Seminary followed in 1867 as a young women's boardinghouse. Finally, the school shown in the photograph was built on Model Avenue in 1888. Originally a two-story school with four rooms, it grew to six rooms in 1899 and to eight rooms in 1907.

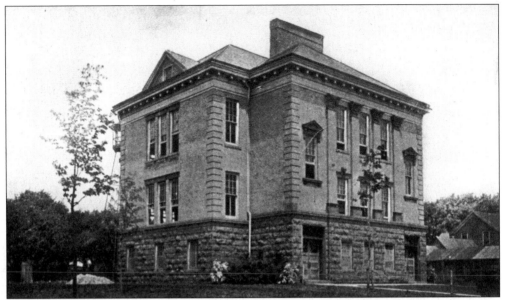

HOPEWELL HIGH SCHOOL. Built in 1910 to serve the ever-growing population of Hopewell Borough, this stone high school building was used for 19 years, until a much larger building was built in Pennington to serve the secondary school population of both boroughs and the rest of the township. Located at the corner of South Greenwood and Columbia Avenues, the building shown in this photograph was later used to house municipal services.

CENTRAL HIGH SCHOOL. This modern building was designed as a two-story brick Colonial revival by J. Osborne Hunt and was erected in 1929. Hopewell Borough citizens were so angered by the location chosen for the school—on South Main Street in Pennington—that they withdrew from the school district and chose to maintain their own elementary school and pay tuition for their high school students to go to Princeton.

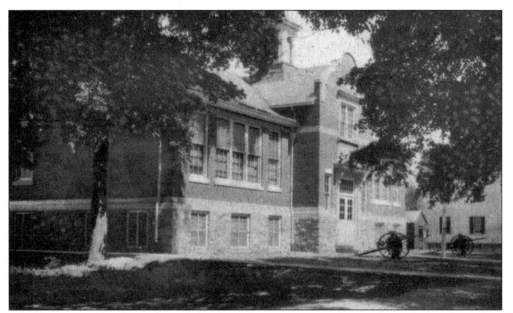

THE TITUSVILLE SCHOOL. This school began as a one-room frame structure built *c.* 1892 to serve the needs of Hopewell Township school district 13. It was expanded by the addition of a second room *c.* 1910. The large brick front shown in this photograph was added in 1922. The Titusville School was abandoned by the township in the 1970s but later became a private school.

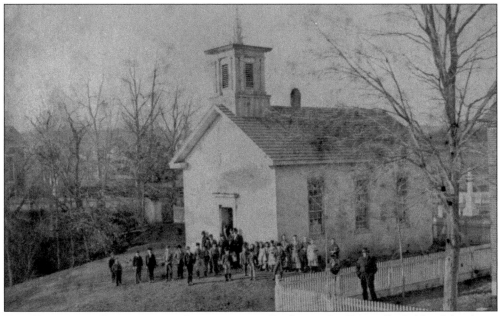

THE TITUSVILLE PRESBYTERIAN SCHOOLHOUSE. Predating the Titusville Public School was the Titusville Presbyterian Schoolhouse, built in 1857-58 to replace an earlier school that had been built in 1849. This school was located in what is today the Presbyterian church cemetery, and it was used as a parochial school until *c.* 1900. It was later demolished.

103

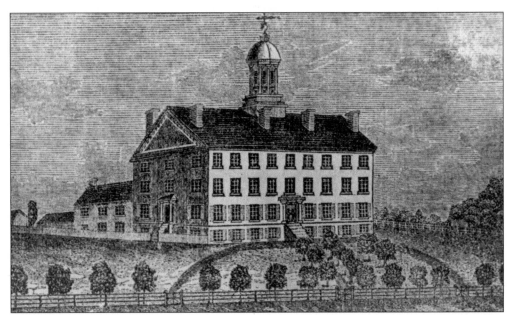

THE METHODIST MALE SEMINARY, 1839. Founded in 1838, the Methodist Male Seminary was built at the behest of the Methodist Conference of New Jersey by Rev. John Knox Shaw, pastor of the Pennington Methodist Church. Shaw raised $5,000 in pledges from the villagers in Pennington and as a result, the church leaders chose the small village as the site of their first school in New Jersey. The school opened with three students.

THE PENNINGTON SEMINARY, 1895. For the first 13 years of its existence, the seminary enrolled only men. After renovations and additions, it became coeducational in 1853 and had further building changes in 1867–68, 1879, and 1885. Pictured in 1895, the school returned to educating only males in 1910. Today, it is a thriving coeducational preparatory school known simply as the Pennington School.

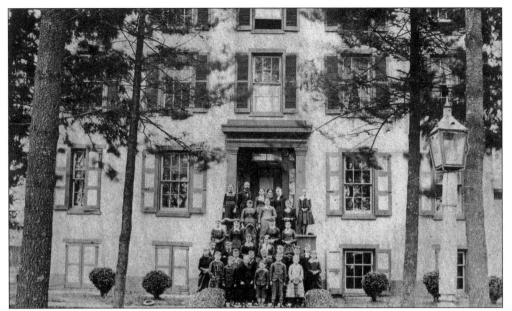

EVERGREEN HALL. The first seminary in Hopewell Valley was Evergreen Hall, a private school for girls, built in the village of Pennington on South Main Street in 1836. The building was three stories high and was constructed of brick. In 1841, it was sold to men from the Presbyterian church, but it always functioned as a private, non-parochial school.

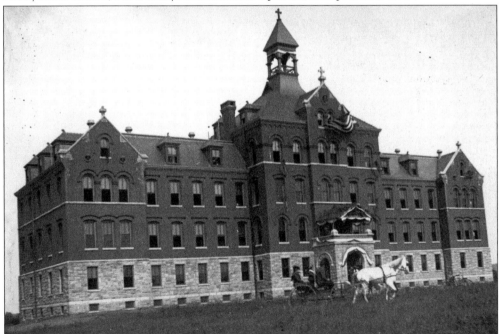

ST. MICHAEL'S ORPHANAGE. Just outside the borough of Hopewell, the Catholic diocese of Trenton built this enormous orphanage, which opened in 1898 with 80 school-age children brought from the smaller St. Mary's home in New Brunswick. By 1943, at its peak, the orphanage housed and educated 416 children. Gradually, large group homes fell out of favor and by 1973, St. Michael's closed and the building was demolished.

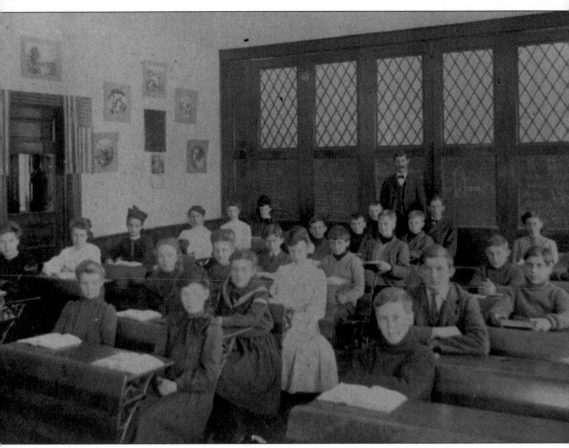

A CLASSROOM IN THE SCHOOL ON ACADEMY AVENUE. The first public schools in Pennington included one used in the 18th century that stood next to the Presbyterian church. It was replaced as the village school by the Pennington Academy c. 1817 and then by the Pennington Public School, built c. 1857–58. In 1900, the school illustrated here was built on Academy Avenue. It served as the borough's primary school until the Pennington Grammar School was completed in 1926. Pictured in 1905, from left to right, are the following: (row closest to the door) Pauline Mathews, Jessie Durling, Bertha Morrell, Marion Errickson, Lida Reed, and Elizabeth Atwood; (second row from left) Edith Morrell, Amy Mershon, Helen Bassett, Joseph Jamison, Earl Teel, Eddie Brennan, and Thomas Ryan; (third row from left) Nellie Primmer, Eleanor Young, Edna Hart, Walter Radcliffe, Leroy Trudel, Zay Jamison, and William Woolsey; (row on right) Stanley Hart, Earl Chatten, Harry Berrien, Chauncey Chatten, Wilbur Harris, and Charlotte Wolfe. Prof. Elmer D. Wagner stands in the back.

Eight

MEN IN UNIFORM

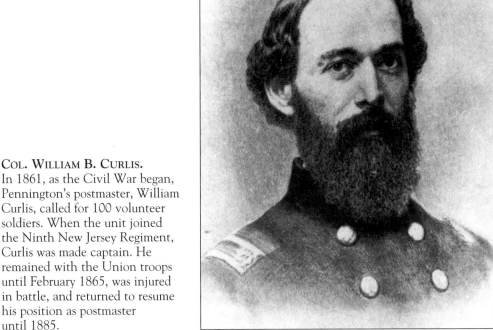

COL. WILLIAM B. CURLIS.
In 1861, as the Civil War began,
Pennington's postmaster, William
Curlis, called for 100 volunteer
soldiers. When the unit joined
the Ninth New Jersey Regiment,
Curlis was made captain. He
remained with the Union troops
until February 1865, was injured
in battle, and returned to resume
his position as postmaster
until 1885.

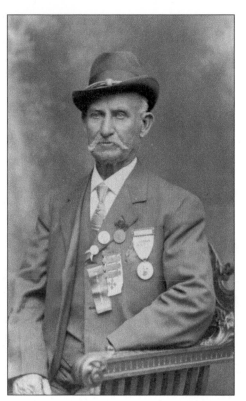

CIVIL WAR VETERAN JOSEPH THOMPSON.
One of the young men who answered William Curlis's call for volunteers in 1861 was Joseph Thompson, who spent the next four years in the service. After the war, he returned to Pennington and spent 37 years working for the railroad. He is shown in 1913, after attending a large encampment at Gettysburg that reunited Civil War veterans.

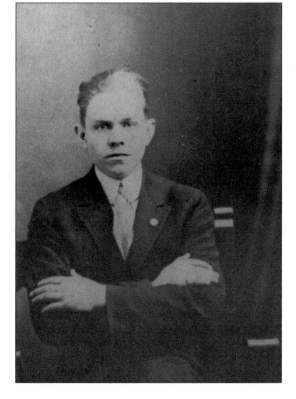

PVT. EDWARD F. CUDNEY. Among the young men of Hopewell Valley who served in Europe in the first World War was Edward Cudney, pictured prior to his enlistment. A member of the 114th Infantry, 29th Division, he was killed in action in France in 1918. His body was not recovered, but a marker was placed on the lawn of St. James Church.

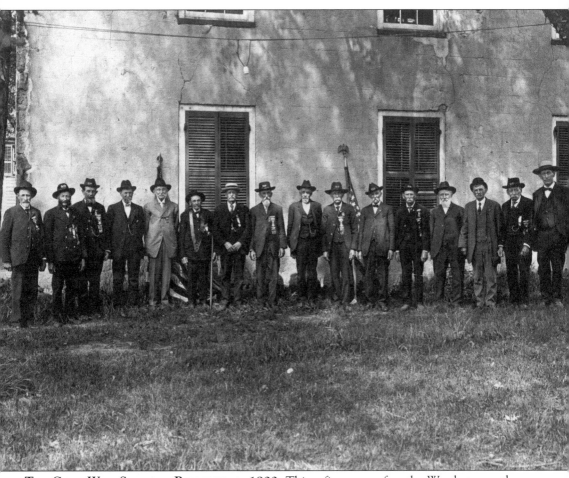

THE CIVIL WAR SOLDIERS REUNION, C. 1900. Thirty-five years after the War between the States came to an end, veterans of that war gathered in Hopewell Borough for a reunion. They were photographed on West Broad Street and are identified, from left to right, as Eli Lawyer, Jacob Wilson, Z.S. Abbott, Jacob Sutphen, J.H. Stout, Richard Savidge, Aaron Cornell, Thomas Skillman, David Fisher, John Piggot, Charles Sernberger, William Mathews, Henry Cox, Joseph Hallenger, ? Conrad, and James Hageman. Other Hopewell residents who took part in the war included Dr. Edward Welling, who served as a surgeon under Colonel McAllister, and George W. Weart and James Manners Weart, sons of Spencer Stout Weart. James Weart had the distinction of being the first man in New Jersey to sign up for Civil War service. Prior to the Civil War, two farmhouses in the Federal City section of Hopewell Township were used as stops on the Underground Railroad, helping runaway slaves escape persecution.

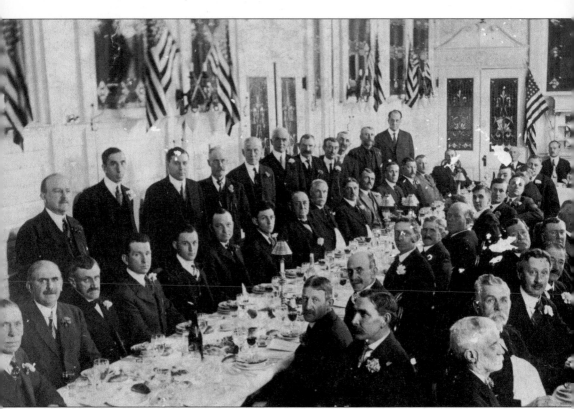

THE PENNINGTON-EWING-HOPEWELL VIGILANT SOCIETY. Members of the society gather on the occasion of their eighth annual dinner, which took place on February 3, 1916, at the Trenton House. It is reported that this society was formed in order to catch horse thieves. Members hailed from Ewing Township, Hopewell Township, and Pennington Borough. It is not clear whether these stalwarts ever succeeded in nabbing any renegade horse thieves or whether there were any to nab in the Hopewell Valley by 1916. Judging from this photograph, the society may have been a men's group that provided a good reason to gather for dinner once a year. Other organizations had preceded this one in Pennington. The Grange had a local chapter by 1824, with 16 original members. The Cyrus Lodge followed in 1878, with 19 charter members. Unlike the Grange, which included both men and women, the Cyrus Lodge was strictly male. Another important organization around this time was the Pennington Improvement Association, founded in 1898. It was run by many of the borough leaders and resulted in much modernization in the borough in the early 1900s.

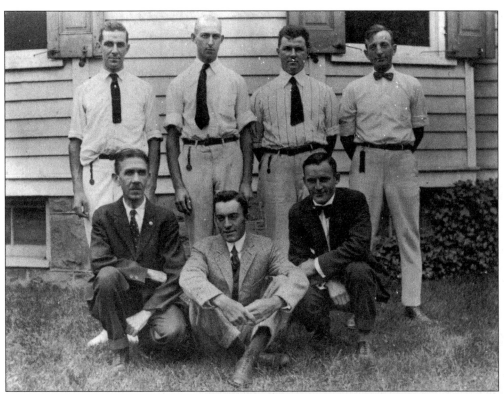

THE TRIANGLE CLUB IN 1920.
In 1901, Charles Titus of the
Pennington Presbyterian Church
formed the Triangle Club out of
young men in his Bible class.
Club members in 1920 include,
from left to right, the
following:(front row) Charles
Titus, Richard Oldis, and Garrett
Oldis; (back row) Paul
Cadwallader, Edgar Kintner, Paul
Blackwell, and Earl Teel.

**STANLEY HART IN UNIFORM,
1899.** This small boy, identified
only as Stanley Hart, stands at
attention, hat by his side, on a
mat that presumably keeps his
well-polished shoes out of the
mud. Is his uniform an imitation
of military garb, or is he ready for
a band concert? More than a
century later, we can only guess.

THE ST. MICHAEL'S ORPHANAGE BAND. This band began as a bugle corps but because of talent, hard work, and dedication, it soon expanded and became famous. The band played all over New Jersey, even dining with the governor, who knew each boy by name. From 1919 to 1926, Rev. John West, who served as chaplain, headed the boys' band.

THE HOPEWELL CORNET BAND. Another band popular in Hopewell Borough in the early part of the 20th century was the Hopewell Cornet Band. Horns were popular instruments at the time because they were inexpensive, easy to carry, and could play a variety of music at high volume in the days before amplification. It is easy to imagine this band entertaining local residents with selections from John Philip Sousa's work.

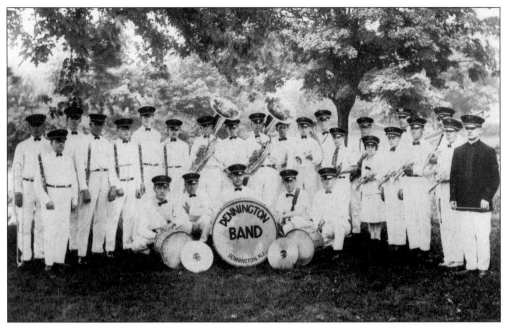

THE PENNINGTON BAND. Pictured on July 4, 1924, the Pennington Band members include the following, from left to right: (kneeling) Douglas Dilts, Clinton Wikoff, Roy Slusser, Arthur Wigley, and Walter Jones; (standing) Ellsworth Broadhead, Ken Martin, Manford Miller, Eugene Voorhees, Frank Chatten, Arthur Miller, John Kuntz, Robert Chatten, Dave Nichols, Harry Ruskie, Fred Skillman, Charles Auletta, Charles Nichols, Richard Sickles, Albert Allen, Emily Nichols, Jack Nichols, William Farr, and Alva Hart.

THE PENNINGTON PUBLIC SCHOOL BASEBALL CLUB. Though baseball on the professional level was still in its infancy when this photograph was taken in 1908, the sport had already grown quite popular on the local amateur level. Clubs such as this one formed in schools and towns, and they played each other on local fields. This picture was taken just west of the public school, which was on the corner of today's Academy Avenue and Burd Street at the time.

113

THE HOPEWELL BASEBALL TEAM. The borough of Hopewell had its own team in the early years of the 20th century, as shown in this photograph. Small town teams often played against teams from nearby locales, and Hopewell's was no exception. While Lambertville and Trenton are mentioned as opponents in articles written at the time, Hopewell's main rival had to be Pennington. On Saturday, August 13, 1904, Hopewell played against the Pennington Athletic Association team for local bragging rights, since the teams had split the prior two contests that season. The game was not as close as expected: the team from Pennington won decisively by a score of 9 to 1. The *Hopewell Herald* back issues are filled with reports on local baseball games; it seems that watching the Hopewell Borough team perform was a popular pastime of summer days a century ago.

THE PENNINGTON ALL STARS BASEBALL TEAM. Pictured as they appeared in 1919 are the Pennington All Stars with their manager, Howard Hoagland. This African American team may have played in the Negro league of the time; clearly, baseball teams were segregated in the Hopewell Valley. Race relations in the valley have been little studied to date, but this photograph suggests that they were not atypical.

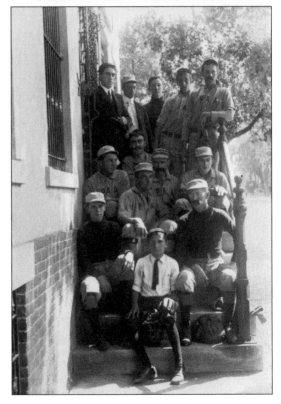

THE PENNINGTON ATHLETIC ASSOCIATION BASEBALL TEAM. Crowding the steps is another Pennington baseball team, this time representing the borough's Athletic Association. An October 1899 article in the *Pennington Post* reports on the initial meeting of this organization, which was to give the young men of the borough a place to meet for their amusement. A 1913 article reports a victory over the Morrisville baseball club by a score of 14 to 1.

115

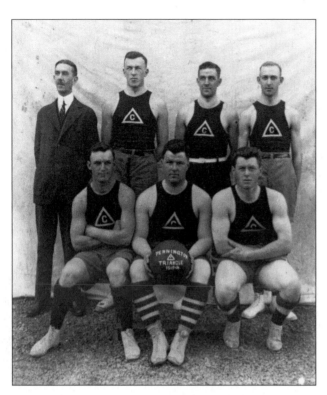

THE PENNINGTON TRIANGLE CLUB BASKETBALL TEAM. The date on the basketball reads 1915–1916, so this team may have played indoor basketball during the winter months. Charles Titus is standing on the left. He was a leader in youth groups and recreational activities in Pennington for many years and in 1927, Titus Hall was added to the Presbyterian church in his honor.

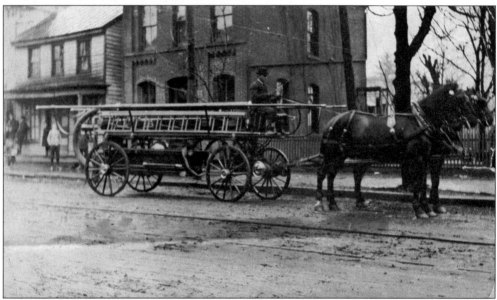

THE FIRST FIRE ENGINE OF THE PENNINGTON FIRE COMPANY. When the Pennington Fire Company was incorporated in 1892, this Button Hand engine was purchased for $439. Nicknamed "Old Bill," presumably sometime later on, it is shown being driven down North Main Street by Fred Sked. Prior to this, fires had been fought with a hand pump engine that featured troughs along the sides for water that came from buckets.

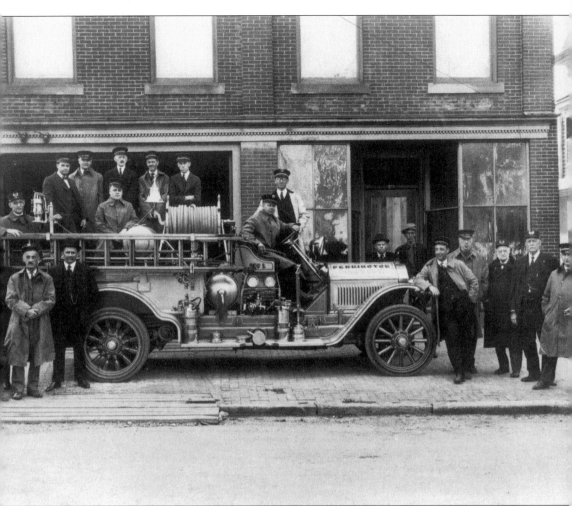

THE PENNINGTON FIRE COMPANY. In 1891, one year after the borough of Pennington was incorporated, Frank T. Hart suggested that volunteers meet to discuss forming the first official fire department. The meeting was a success and Hart was elected its first president. There were 20 charter members in all, including Hart, amateur photographer George Frisbie, future mayor Walter Frisbie, and future founder of the Pennington Triangle Club, Charles Titus. The unit was incorporated in 1892 and over the months that followed, the first fire truck and equipment were purchased. The volunteer firefighters raised money regularly to improve and update their firefighting equipment. A steel tower with a fire bell was erected in 1894. The company initially had its headquarters in a blacksmith shop and then in 1897, moved into the Odd Fellows Hall on North Main Street. It remained there for many years before moving into the new firehouse on Bromel Place.

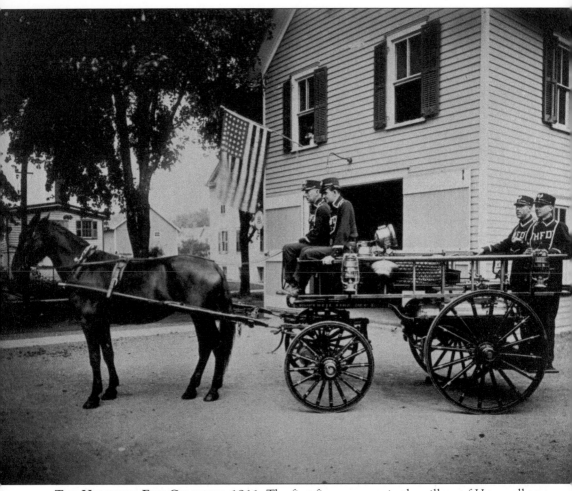

THE HOPEWELL FIRE COMPANY, 1911. The first fire company in the village of Hopewell was the Hopewell Hook and Ladder Company, founded in 1877 and housed in a building on South Greenwood Avenue. Ironically, the firehouse burned down in 1893, leading to the creation of a competing firefighting unit, the Union Fire Company, in 1895. These two fire companies were joined by a third, the Hopewell Fire Department, in 1911, the year this photograph was taken. Among the members pictured is barber Harry Cox, seated on the right in the front of the fire wagon. The three companies competed for several years, until the Union Fire Company and the Hopewell Hook and Ladder Company joined forces in 1917 to form the Union Hook and Ladder Company. Finally, in 1921, the remaining companies merged and took the name of the Hopewell Fire Department. The department was housed in Columbia Hall on South Greenwood Avenue until 1939, when it moved into the building where it remains today.

Nine

CROSSROADS
COMMUNITIES

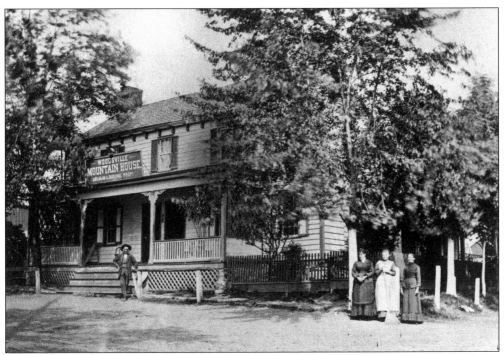

THE WOODSVILLE MOUNTAIN HOUSE, LATE 1800S. Named for Joseph Wood, who established a store and post office *c.* 1820 at the crossroads of the newly completed Georgetown and Franklin Turnpike (Route 518) and what is today known as Marshalls Corner-Woodsville Road, Woodsville was typical of the small communities that dotted the landscape of Hopewell Valley in the 19th century.

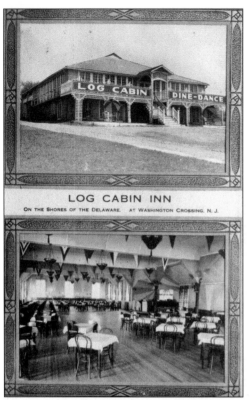

THE LOG CABIN INN, WASHINGTON CROSSING. After the events of December 1776, the hamlet called Washington Crossing developed slowly on the banks of the Delaware River. Known earlier as Eight Mile Ferry, Johnson's Ferry, and Bernardsville, the community became commonly known as Washington Crossing after the Belvidere-Delaware Railroad built a station by the Delaware and Raritan Feeder Canal soon after tracks were laid in 1851.

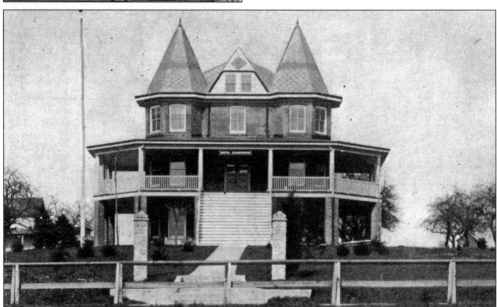

THE HOTEL WASHINGTON, WASHINGTON CROSSING. By the early 20th century, Washington Crossing was becoming popular as a river resort for wealthy denizens of Trenton, just 8 miles to the south. This hotel, built c. 1910, was typical of the ornate style of the times. Improvements in roads and modes of travel began to make an 8-mile journey less arduous than it had been only decades before.

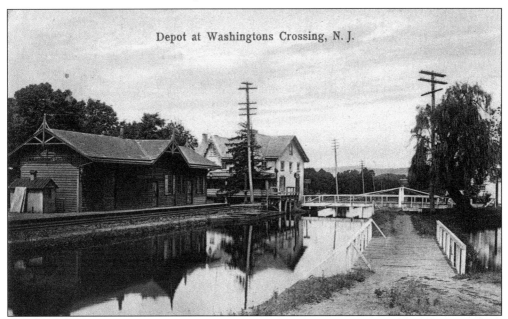

Depot at Washingtons Crossing, N. J.

THE DEPOT AT WASHINGTON CROSSING. The combination of the Delaware River, the feeder canal, the railroad line, and the roads that led south to Trenton and east to Pennington made Washington Crossing a hub for travelers. From the 1700s, when its ferry was a main local route across the Delaware, to today, Washington Crossing has always been an important way in and out of Hopewell Valley.

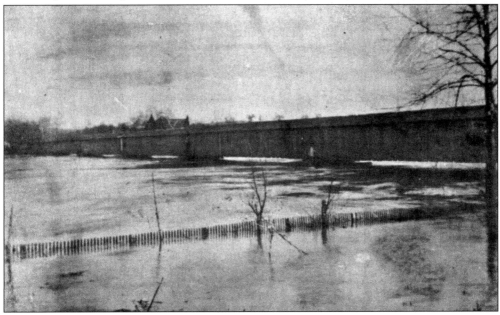

THE WASHINGTON CROSSING COVERED BRIDGE IN THE FLOOD OF 1903. The original ferry that crossed the Delaware River at Washington Crossing went out of business in 1834, when a bridge was built. That structure was destroyed in 1841, but this covered bridge soon replaced it, lasting 62 years until another flood carried it away. This photograph was taken not long before the bridge was destroyed.

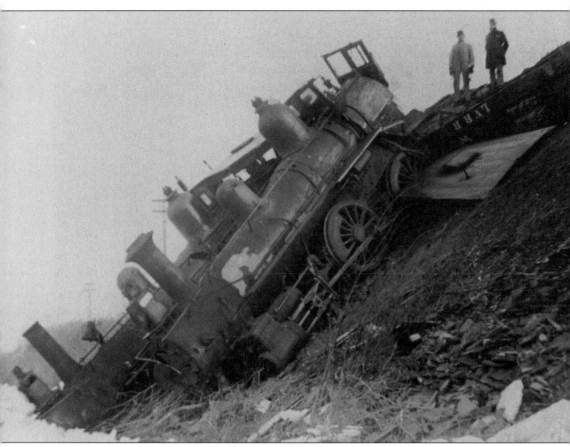

THE AFTERMATH OF A TRAIN WRECK. The scene in Washington Crossing was not always tranquil, for where there is much commerce and travel, accidents occur. On February 17, 1904, at 4 o'clock on a bleak, chilly morning, the darkness was split by the head-on collision of two coal trains on the tracks of the Belvidere-Delaware Railroad. A northbound train of empty coal cars missed a turn of the tracks and barreled headlong into a southbound train of cars filled with coal. The engineer and fireman of the empty train were killed. Ironically, an even worse crash had occurred near that same spot on October 24, 1903, when 24 men died in a rear-end collision.

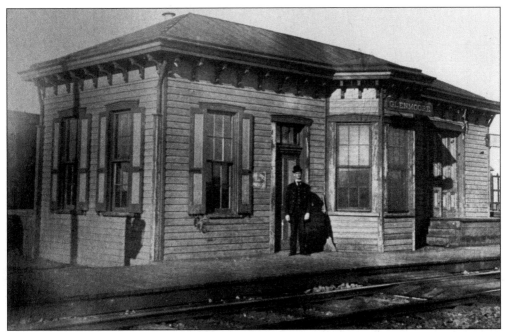

GLENMOORE STATION. By 1720, the first grist mill in Hopewell Township had been established on the Stony Brook 2 to 3 miles west of the Baptist meetinghouse. Called Moore's Mill, it later became the site of this station when the railroad came through in the 1870s. Wealthy rat poison manufacturer Ephraim S. Wells bought land here in the 1890s and renamed it Glenmoore.

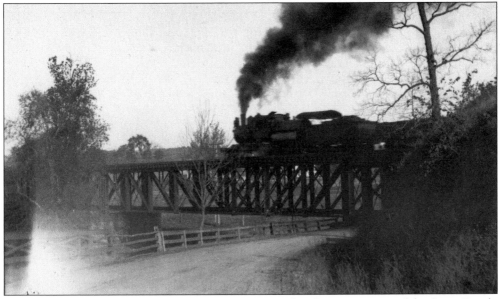

A TRAIN ON THE GLENMOORE BRIDGE, 1898. Located at the intersection of the Stony Brook, Pennington-Hopewell Road, the Delaware and Bound Brook Railroad, and the Trenton Street Railway trolley line, Glenmoore hosted many travelers in the late 19th and early 20th centuries. Here was the only train station in Hopewell Township between Hopewell and Pennington Boroughs. Although the station is long gone, Glenmoore's farmhouse is now part of the Hopewell Valley Golf Club.

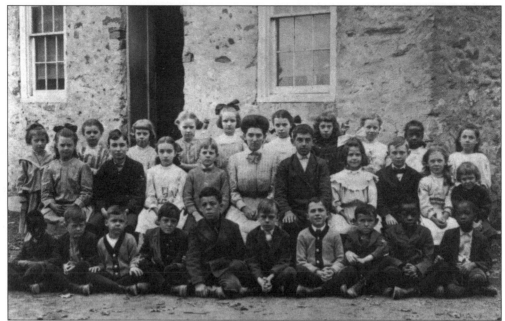

THE MARSHALLS CORNER SCHOOLHOUSE STUDENTS, 1908. Marshall's Corner was a small hamlet located in Hopewell Township at the intersection of Pennington-Hopewell Road and Marshalls Corner-Woodsville Road. Pictured is the class of 30 children from grades one through seven. In the front row, fourth from right is Russell Boroughs. The teacher, Madge Weidenhamer, is not shown.

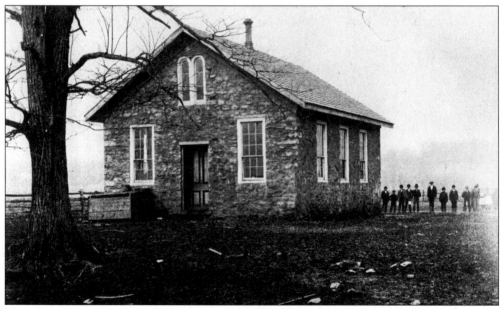

THE MARSHALLS CORNER SCHOOLHOUSE, 1876. This earlier photograph better shows the small stone building, built c. 1825, which housed the students of Hopewell Township School District 11 until 1930. It survives today with a new addition on the front as a Lion's Club meeting place. Marshalls Corner was bypassed as a center of activity when Route 31 was built just to the west of the crossroads.

THE MOUNT ROSE DISTILLERY. Not far west of the current intersection of Carter Road and Pennington-Rocky Hill Road stands this abandoned brick building, symbol of a business that thrived in the village of Mount Rose in the second half of the 1800s. Apple whiskey was made at two stills on either end of Mount Rose, using apples grown locally. Reportedly, the distiller charged 10 percent of the product for his services.

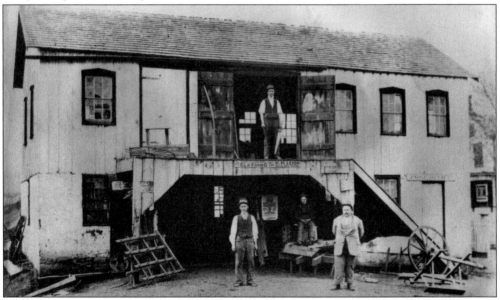

THE STOUTSBURG BLACKSMITH SHOP AND POST OFFICE. This small village was located at the eastern edge of Hopewell Township where today, Route 518 crosses Province Line Road. It flourished in the second half of the 1800s and even had a train stop during the brief existence of the Mercer and Somerset Railroad. Stoutsburg has essentially disappeared, for no historic buildings from this village survive on the Hopewell Township side of Province Line Road.

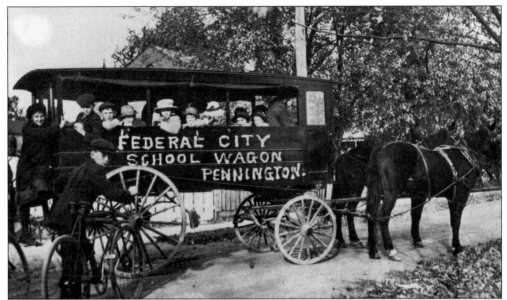

THE FEDERAL CITY SCHOOL WAGON, 1916. The many residents who travel daily on Federal City Road may not be aware of its history, which dates back to the American Revolution. In the 1780s, the area surrounding the crossroads of today's Federal City Road and Pennington-Lawrenceville Road was one of the sites proposed for the new nation's capital. George Washington and the southern states opposed it, but for a time this portion of Hopewell Township had a chance to become the seat of the new American government. Federal City Road was laid out in 1817, and a small village developed and declined by the early 1900s. Hopewell Township School District 9 was housed in a one-room schoolhouse here, which was abandoned in 1910 and which burned to the ground in 1915.

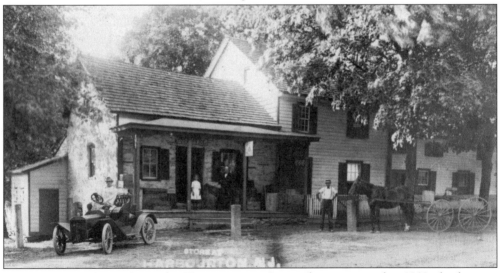

THE POST OFFICE AND STORE AT HARBOURTON. Pictured as it appeared in 1908, this historic site survives today as a residence. Samuel Burns sits in his 1908 Ford Runabout; Helen Jones and Silas Lawrence sit on the porch; Joseph Johnson stands by his horse. Found where Harbourton-Mount Airy Road meets Route 579, this village also included a church, built in 1879 to replace an earlier structure built in 1805.

126

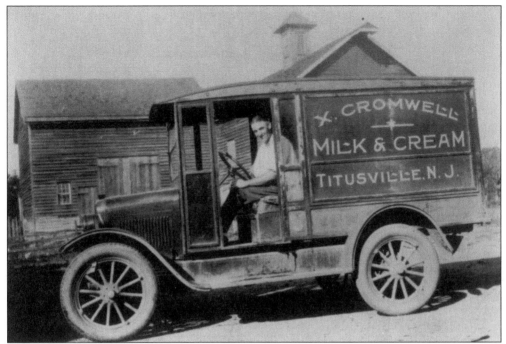

XENOPHON CROMWELL IN 1926. Visitors to the popular Howell Living History Farm are actually seeing the site of an old dairy farm owned by Xenophon Cromwell from 1920 to 1948. The Howells owned the farm from 1962 to 1974, but it originated as the John Phillips farm in 1737. The farm and surrounding Pleasant Valley Historic District are both listed on the National Register of Historic Places.

PHOTOGRAPH CREDITS

From the collection of **Christopher Bannister, courtesy of Karen Bannister**, come the images on the following pages: 4, 9, 18, 20, 21 (top), 34 (top), 35, 37, 38 (top), 39 (top), 41-42, 60 (bottom), 83-84, 86-88, 100-101, 102 (top), 112 (bottom), 113 (top), 114, 119, 123 (top), 124 (bottom). Some of the images in the Bannister collection may be property of the **Hopewell Museum**, and our thanks is given to the museum for permitting them to be used.
Images on pages 38 (bottom), 66, 74, and 85 courtesy of **David Blackwell**.
Image on page 39 (bottom) courtesy of **Bea Castoro**.
Image on page 96 (top) courtesy of **Jack Davis**.
Image on page 2 courtesy of **Jerry Farina**.
From the **George H. Frisbie collection of the Hopewell Valley Historical Society** come the images on the following pages: 11 (bottom), 21 (bottom), 22 (bottom), 23, 24 (top), 28, 29 (top), 30 (top), 31, 32, 46, 50-53, 57, 59, 60 (top), 61 (bottom), 62 (top), 63, 68, 69, 71, 72, 73 (top), 75 (bottom), 76, 77 (top), 78 (top), 79, 105 (bottom), 111 (bottom), 115 (bottom), 116 (top), 123 (bottom).
Image on page 118 courtesy of the **Hopewell Fire Company**.

From the collection of the **Hopewell Museum** come the images on the following pages: 16, 43, 79, 109, 125 (bottom).

From the collections of the **Hopewell Valley Historical Society** come the images on the following pages: 13 (top), 14 (bottom), 30 (bottom), 40 (bottom), 77 (bottom), 78 (bottom), 127 (top).

Image on page 127 courtesy of the **Howell Living History Farm**.

Images on pages 12, 61 (bottom), 98, and 105 (top) courtesy of **Jack Koeppel**, as are the engravings from the *1875 Combination Atlas Map of Mercer County* found on pages 17, 19, 22 (top), 24 (bottom), 36, 90 (top).

Image on page 126 (bottom) courtesy of **Mike Laracy**.

Image on page 112 (top) courtesy of **Marion McCandless**.

From **Bob and Carol Meszaros** come the images on pages 13 (bottom), 34 (bottom), 44, 48, 49 (top), 62 (bottom), 89, 103 (top), 120-22.

Images on pages 80-82 courtesy of the **New Jersey State Police Museum**.

Images on page 116 (bottom) and 117 courtesy of the **Pennington Fire Company**.

Images on pages 45, 49 (bottom), 90 (bottom), 91, 103 (bottom) courtesy of **Miles Ritter**. Several of these images are also from the **Bannister** collection.

From the collection of **St. James Roman Catholic Church** come the images on the following pages: 11 (top), 25, 26 (top), 27, 29 (bottom), 33, 47, 54-56, 64-65, 67, 70, 73 (bottom), 75 (top), 92-95, 96 (bottom), 97, 99, 102 (bottom), 104, 106-108, 110, 111 (top), 113 (bottom), 115 (top), 124 (top), 125 (top), 126 (top).

Image on page 10 courtesy of **Thomas Seabrook**.

Image on page 40 (top) courtesy of **Janet Six**.

Image on page 78 (bottom) courtesy of **John and Sue Van Selouf**.

Image on page 14 (top) courtesy of **Washington Crossing State Park**.

Image on page 15 is the authors' own.

MAJOR WORKS CONSULTED

Ege, Ralph. *Pioneers of Old Hopewell*. Hopewell, N.J.: Hopewell Museum, 1908. Reprint, 1963.

Gantz, Elizabeth. *Hopewell's Past*. 1975–83.

Gray, Nomer. *Healthful, Historic Hopewell*. Hopewell, N.J.: C.E. Voorhees, 1897.

Hopewell Herald, 1900–1910.

Hammond, Cleon E. *John Hart: The Biography of a Signer of the Declaration of Independence*. Newfane, Vt.: Pioneer Press, 1977.

Hunter, Richard W. and Richard L. Porter. *Hopewell: A Historical Geography*. Titusville, N.J.: Township of Hopewell Historic Sites Committee, 1990.

Ketchum, Richard M. *The Winter Soldiers: The Battles for Trenton and Princeton*. New York: Doubleday, 1973.

Lewis, Alice Blackwell. *Hopewell Valley Heritage*. Hopewell, N.J.: Hopewell Museum, 1973.

O'Connell, Margaret J. *Pennington Profile: A Capsule of State and Nation*. 2nd ed. Pennington, N.J.: Pennington Library, 1986.

Orations, Sketches and Exercises, 1865–1926. Hopewell, N.J.